REMEMBERING

BANGOR

REMEMBERING

BANGOR

THE QUEEN CITY BEFORE THE GREAT FIRE

WAYNE E. REILLY

Charleston London

THE
History
PRESS

Published by The History Press
Charleston, SC 29403
www.historypress.net

Front cover: Bangor's waterfront. *Courtesy of Richard R. Shaw.*
Back cover: A saloon on Exchange Street. *Courtesy of the Bangor Museum and History Center*; Italian immigrants. *Courtesy of the Fogler Library Special Collections, University of Maine.*

First published 2009

Manufactured in the United States

ISBN 978.1.59629.590.2

Library of Congress Cataloging-in-Publication Data

Reilly, Wayne E., 1945-
Remembering Bangor : the Queen City before the great fire / Wayne E. Reilly.
p. cm.
Includes bibliographical references.
ISBN 978-1-59629-590-2
1. Bangor (Me.)--History--Anecdotes. 2. Bangor (Me.)--Social life and customs--Anecdotes.
3. Bangor (Me.)--Biography--Anecdotes. I. Title.
F29.B2R456 2009
974.1'3--dc22
 2008046776

To the old-time reporters and editors of the Bangor Daily News *and the* Bangor Daily Commercial—*your names may have been forgotten, but your work provides a portal to the past that grows more important daily.*

CONTENTS

CONTENTS

PREFACE

The newspaper columns reprinted in this book were first published between 2003 and 2008 in the *Bangor Daily News*. Each bears the original date of publication, corresponding with an event or trend that occurred a century ago, during the first decade of the twentieth century, before the Great Fire of 1911 devastated much of the old Bangor described here. At that time, the city was in transition between its glory days as the lumber capital of the world and its more prosaic status as the major service center for that vast, ill-defined area called Eastern Maine. In 1899, the secretary of the Bangor Board of Trade still had the audacity to predict that his city was "rapidly coming to the front as the metropolis of the Northeast." Cooler minds, however, could already see that while the Queen City of the East would be known for its manufacturing and its harbor perhaps a bit longer, it would eventually settle for being a respectable center for healthcare, education, shopping, entertainment, banking and the like.

I gathered material for these stories mostly from century-old editions of the *Bangor Daily News* and the *Bangor Daily Commercial* stored on microfilm at the University of Maine. These newspapers—one catering to Republicans and one to Democrats, and both appealing to readers who liked their news with a bit of sensationalism—would compete against each other for the next fifty years. The fierce rivalry usually guaranteed that if one passed over an important story, the other would have it in a day or two. When I couldn't get enough background from the newspaper accounts, city directories and public reports of the era, I turned to works by such distinguished historians as James B. Vickery, Deborah Thompson, David C.

Smith and Louis C. Hatch. If I continued to be stumped, I knew that my friend and former colleague at the *Bangor Daily News*, Dick Shaw, could help me fill in the blanks from his prodigious newspaper archives. Where was the Red Bridge neighborhood? Pol's Corner? High Head? When was the first telephone hooked up in Bangor? When did the first automobile drive into town? When did the city send its first salmon to the president of the United States? Dick's generosity in sharing information and photographs from his extensive collection (plus the availability of his published volumes of Bangor photographs with informative cutlines) has been an important factor for me in gathering information under deadline.

Bangor was a far different place a century ago. Thousands of immigrants from Russia, Italy, Sweden, Syria and other exotic spots walked the streets. Great buildings like Norombega Hall and Union Station still served as a reminder of the city's distinguished past. Red-shirted loggers and wind-weary sailors still caroused on Exchange and Broad Streets. Vast changes lay ahead, however. Bangor's harbor was dying as a port, as were the legendary log drives. The pulp and paper mills farther upstream and the railroad lines that hauled lumber to the sea were rearranging the economy. The mighty Penobscot River was increasingly abandoned to the pollution that helped end the ice industry and public recreation.

Bangor was still a gaudy show town where you could see Broadway plays with the original casts at the opera house or famous operas at the auditorium or city hall. Big circuses and fairs attracted tens of thousands of people in the summer. Bangor's first movie and vaudeville houses were built during this period, however, and they would modify entertainment tastes drastically. The coming of the automobile, the expanding trolley system, the motorboat, the telephone and even the new department stores were picking up the pace of life. This old Bangor before the Great Fire was still a spirited place where hundreds of illegal barrooms and brothels existed a few steps away from fine mansions and concert halls, but it was time to modernize, and the Great Fire of 1911 helped that process along. The days of men like William Conners, the "log king of the Penobscot," were about over, while men such as John R. Graham, the trolley magnate and electrical wizard, helped point the way to the city's future. In these columns, I have tried to capture their spirit, as well as the spirit of the nameless, faceless immigrant hordes on Hancock Street who came looking for a better life but have largely remained silent in history books.

Besides Dick Shaw, many people have helped me. Nearly all my research was conducted at the University of Maine in the Fogler Library microfilm room. A lion's share of my thanks, therefore, goes to the unsung heroes of

this important resource who keep the microfilm rolls in order and maintain the reading machinery. They invariably have been helpful and polite during my weekly visits.

I have also consulted many staff members at libraries, historical societies and museums. Some who have been repeatedly helpful include Bill Cook and Elizabeth Stevens at the Bangor Public Library's Local History Room; Dana Lippitt at the Bangor Museum and History Center; Charlie Campo at the *Bangor Daily News*; Brenda Steeves at the University of Maine Fogler Library's Special Collections; Earle Shettleworth Jr. at the Maine Historic Preservation Commission; Jamie Kingman-Rice at the Maine Historical Society; and Pauleena MacDougall at the Maine Folklife Center, University of Maine. A large number of reference librarians at the Bangor Public Library and the University of Maine's Fogler Library have also been unfailingly patient and helpful, answering my questions and orienting me to useful material on numerous occasions.

Special thanks to A. Mark Woodward, executive editor at the *Bangor Daily News*, for encouraging me to write these columns and to my editors Letitia Baldwin and Dale McGarrigle for overseeing their production on a weekly basis, as well as to the many *BDN* page designers, copyeditors and other staffers involved in the process.

Finally, I owe more than I can say to my wife, Karen Roseen Reilly, who until recently was library director at Eastern Maine Community College in Bangor. Her research skills, her sharp editorial eye and, most importantly, her consistent encouragement and interest have provided me with an undying source of energy.

THE LAST OF THE
LUMBERMEN

FROM LUMBER TO CIGARS, BANGOR WAS A
MANUFACTURING TOWN

October 9, 2006

A century ago, Bangor manufactured more cigars than any other town in Maine. Six producers—Benjamin F. Adams, W.S. Allen, Central Cigar Co., Albert Lewis, Madine Cigar Co. and James J. O'Leary—kept up a steady flow of stogies to the city's twenty-four cigar and tobacco dealers. This was back in the days when a man lit up a good cigar after dinner or while reading his newspaper.

Bangor's cigar supremacy was only one of the many reasons Bangoreans believed their city was deserving of its nickname, the Queen City of the East. Edward M. Blanding, secretary of the board of trade, editor of the *Industrial Journal* and consummate Bangor booster, compiled a bragging list with this and other items on it. On the morning of October 24, 1906, this list was published in the *Bangor Daily News*, doubtlessly warming the hearts of more than a few residents who were not looking forward to another long, cold winter in this small, isolated lumbering metropolis situated increasingly far from the mainstream of American commerce. Blanding's list, which took up most of a newspaper page, tells us as much about the aspirations of local folks as it does about what Bangor was like.

Bangor was a manufacturing town back then. It had banks and hospitals and social agencies, and it benefitted from the state's growing hunting and

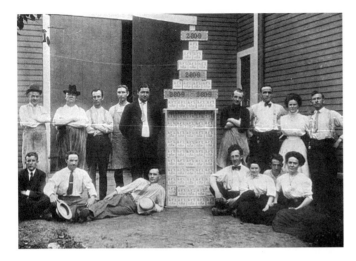

Adams Cigar Factory employees posed at their headquarters at 289 State Street in 1905. *Courtesy of the Bangor Museum and History Center.*

Rafts of logs and lumber still floated down the Penobscot River to Bangor in the first decade of the twentieth century, but the city's famed lumber trade was much reduced.

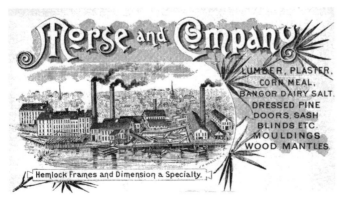

Morse and Company mills on the banks of the Kenduskeag Stream were famous for lumber, house interiors, furniture and other wood products.

tourism trade, but it was first and foremost a place where raw materials were processed for the wider world. "[Bangor] has manufacturing establishments numbering about 300, embracing many and diverse industries and employing several thousand hands," wrote Blanding. Besides cigars, those manufactured goods included lumber, picture frames, clothing, boxes, bedsprings, bricks, ships, canoes, trunks, moccasins, boots, shoes, saws, axes, cant dogs, sawmill machinery, stoves, furnaces and crackers. Of some items, Bangor was the largest producer in Maine, New England or even the entire country.

Essential to this manufacturing, Bangor was an important transportation hub, starting with its

> *fine harbor, easily accessible and entirely safe for vessels of large size, there being several miles of deep water frontage and the docks at High Head afford excellent facilities for the larger craft, either steam or sail, engaged in foreign commerce and the ocean carrying trade.*

Eighty-seven vessels were "registered or enrolled" at the port of Bangor, including seventy-eight sailing vessels, seven steamers and two steam yachts.

Vessels arriving in the port in the past year had numbered 1,545. More than 187 million feet of lumber had passed through the harbor, a quantity not exceeded since 1872, when Bangor earned its reputation as the lumber capital of the world. Exports also included nearly 7 million feet of white birch spool bars headed for mills in England and Scotland and 1.5 million feet of box shooks bound for ports in Italy. Imports included 361,689 tons of coal to fuel local enterprises, as well as the growing number of paper mills that dotted the river from Brewer to Millinocket.

Of course, even then the railroads and other ports along the coast were replacing Bangor's harbor as a center for shipping. The Maine Central Railroad (MCRR) and the Bangor & Aroostook (B&A) Railroad connected Bangor with the rest of the world via the Canadian Pacific and other lines. "There are 84 regular trains in and out of Bangor daily, 62 of these passenger trains and 22 freight, besides numerous special trains," wrote Blanding. The B&A had just opened its own port at Searsport and Stockton, threatening to eclipse Bangor's harbor.

The Bangor electric street railway was another important part of the transportation web. In the past year, more than four million people had traveled along the system's sixty miles of track operated by the Bangor Railway & Electric Company, which had just built the first "concrete car

stable" in Maine. Residents had traveled nearly a million miles on the trolleys from Old Town to Hampden and from Bangor to Charleston.

Other impressive examples of Bangor's modern infrastructure included a new steamship terminal and a big auditorium where famous opera singers performed. A new railway station was under construction. An opera house, a fine YMCA building and the Bangor House, the biggest hotel in Maine (open year-round), were also worth noting.

New technology, however, excited Bangor's premier booster the most. For example, the New England Telephone and Telegraph Company reported twenty-eight hundred subscribers in the city proper and another thirty-three hundred in outlying towns. Bangor's record of one telephone for every ten people was equaled by few cities in the country, claimed Blanding.

It was electricity that caused Blanding to wax most enthusiastically. Bangor was "universally conceded to be one of the best lighted cities on the entire globe," he enthused. The Bangor Railway & Electric Company operated 37,900 electric lights in Bangor and vicinity. That amounted to a national record of one and a half lights for each person who lived in the area. These lights were not to be confused with Bangor's electric streetlights, which were powered by the city-owned waterworks, or with the lighting provided by the Bangor Gas Light Company, which burned coal and shipped the gas for lighting and cooking around the city through thirty-five miles of gas mains. Use of the latter had increased 60 percent in the last decade.

"Cheap electric power at tidewater means much for Bangor, and this is destined to be an important factor in the development of the city along industrial lines," said Bangor's great booster in that age long ago before commercial trucking, air travel or the high-speed Internet.

Harbor's "Maze of Masts" Was Declining

September 25, 2006

Once a proud thoroughfare of commerce, the mighty Penobscot River was already in trouble a century ago. Like many other water routes across the nation, people were turning their backs on the river as boat traffic declined and pollution increased.

A short editorial in the *Bangor Daily News* on July 13, 1906, entitled "The Future of Bangor" summed up part of the story. Old-timers noted that there was less shipping in the river that year than in previous years. The great

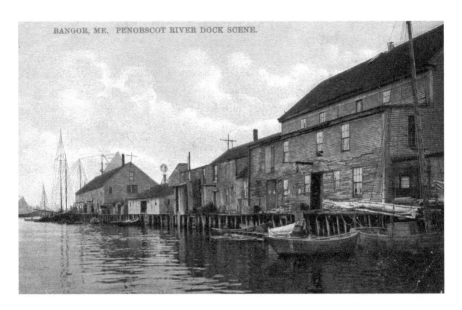

Bangor Harbor as it looked early in the twentieth century when business was declining.

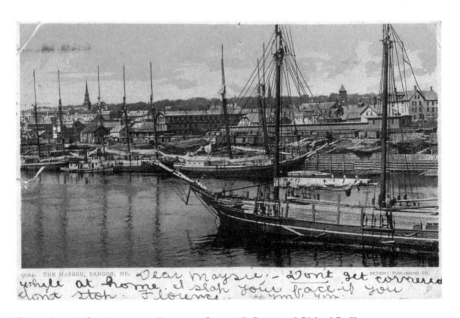

Bangor's waterfront was once "a maze of masts." *Courtesy of Richard R. Shaw.*

"maze of masts" that once visited Bangor Harbor beginning each spring was much reduced.

Many tons of lumber, potatoes and coal were bypassing the Queen City's little harbor for new docks in Stockton Springs and Searsport at the end of the new Bangor & Aroostook Railroad's branch line to the sea. The editorial writer noted:

> Coal that formerly was discharged at High Head [on the Bangor waterfront] is now discharged at Cape Jellison. Lumber from the upriver mills that used to be piled upon what was called the "Ashland Pier," never sees Bangor at all these days, but goes right through to open water.

The decline of Bangor's port didn't hurt business overall in Eastern Maine, admitted the writer, but it was humiliating to local pride.

The paper's waterfront reporter recorded other signs of decline on November 7:

> At this time of the season in former years the stevedores have been so busy discharging vessels that the work was carried on 24 hours in the day with three shifts of men, and schooners and barges were forced into paying demurrage because they could not be provided with discharging berths fast enough. Rarely this season have the docks been full so that incoming vessels have been obliged to wait at Fort Point until room was made for them.

River traffic would be all but moribund within two or three decades, and the Penobscot, like many American rivers, would be a filthy sewer. In fact, it already was a sewer in 1906. The current generation of environmentalists likes to think it discovered water pollution, but thoughtful people could already see the handwriting on the wall a century ago, as another editorial in the *Bangor Daily News* demonstrated on October 26. It was entitled "Polluted Rivers." Three results of pollution were highlighted.

First, the building of mills and dams in the Kennebec River had rendered salmon nearly extinct. The same would soon happen in the Penobscot if the legislature didn't take action. So long as the mills continued to discharge into the river, there would never be any hope of reviving the salmon industry in the downriver weirs.

The second result of pollution was the recurrence of typhoid fever. Outbreaks had killed dozens of people along the river in the past few years. The paper often ran pieces urging residents to boil river water before

drinking it. "The only [long-term] safety which is available seems to be the construction and maintenance of a perfect filtration plant for Bangor and Brewer and Old Town and other places which take their water from the river," said the editorial.

A third problem was the impact of pollution on the ice industry. It was becoming more and more difficult to carve untainted ice from the Penobscot.

The only way to assure clean ice next December is to clean up the river banks and lowlands and remove or burn every chip or bit of bark or rotting wood that may be found. There is not a sawmill from Orrington to Medway from which a freshet or a high tide would not carry away cords of objectionable matter and float the mass into the river to drift around for days and weeks.

Of course, this would do nothing to clean the ice of the raw sewage that was being dumped from communities up and down the river or the cinders from the locomotives that ran along its banks.

The concerns of the lone *Bangor Daily News* editorial writer in 1906 sound old-fashioned compared to those of today's environmental reformers. He was concerned about the decline of two businesses—fish and ice—as well as a disease that has all but been eradicated in the United States. Today's concerns revolve around the creation of a new economy that markets recreational opportunities on pristine rivers and wild lands, as well as the poisonous impact of toxic waste on people's health in ways undreamed of a century ago.

Our old editorial writer would not have been too happy with today's emphasis on recreation as a form of economic salvation. After the Boston & Maine Railroad advertised Maine as the "playground of America," he wrote an editorial on October 19, 1906, stating that a good portion of Mainers resented the designation. Everybody knew that advertising Maine as a playground was damaging to the state, he said. Sportsmen and pleasure seekers would never keep Maine economically healthy.

Before Maine can take her place among the foremost states in the union, she must create new industries and develop old industries. She must build factories and machine shops and mills to keep the young men from going to Boston and New York...The tide of humanity which has been ebbing from Maine since the close of the Civil War must be stopped.

Those words sound familiar, yet oddly antique today. The idea of Maine as a playground state has gained widespread acceptance. High technology services are rapidly replacing the mills that were in their heyday back when the old editorial writer was condemning pollution and calling for more factories, unable to see at that early date the contradictions inherent in such a position.

WILLIAM CONNERS, LOG KING OF THE PENOBSCOT

November 12, 2007

William Conners was the "Log King of the Penobscot," declared the *Bangor Daily Commercial* on November 2, 1907. When Conners died fourteen years later at age eighty-six, both the *Bangor Daily News* and the *Commercial* agreed that he was one of Maine's most famous lumbermen. What could one log driver have done to deserve such adulation in the land of the Bangor Tigers—those doughty knights of the cant dog who risked their lives herding logs down the Penobscot to market?

Longevity gave Conners's fame a boost, as well as an aura of nostalgia. Bangor was dying as a lumber port. It had been the lumber capital of the world

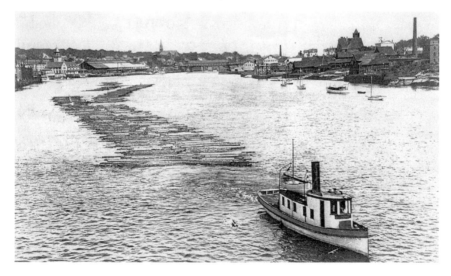

The tug *William Conners* hauled rafts of logs through Bangor Harbor to local mills. *Courtesy of Richard R. Shaw.*

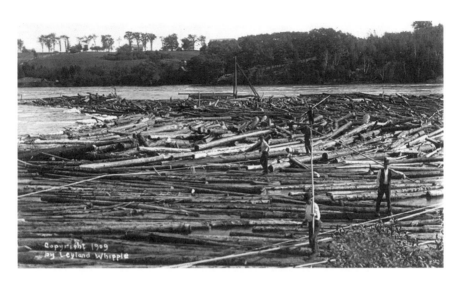

A log jam at the Bangor Boom. *Courtesy of Richard R. Shaw.*

once upon a time, as everyone knew. By 1907, when the *Bangor Daily Commercial* called him the log king, Conners was completing his forty-third year as the contractor in charge of the Bangor Boom, the storage point for logs on their way to local sawmills and for lumber sawed upriver and destined to be shipped to markets around the world. He had been in charge since the Civil War.

A boom was a line of logs connected at the ends used to corral logs floating down the river. The *Bangor Daily News* described the Bangor Boom on November 13, 1903:

> *The boom is partly above and partly below the great* [Bangor Water Works] *dam at the head of tidewater on the Penobscot, and within its enclosure are sorted and rafted all the logs from the headwaters that are intended for manufacturing in the steam mills at and below Bangor. There are six of these mills—those of Morse & Co., F.H. Strickland, the Eastern Mfg. Co., Sargent Lumber Co., Lowell & Engel and the Sterns Lumber Co.*

William Conners was one of the last symbols of Bangor's glory days, when it was said you could cross the river between Bangor and Brewer by stepping from the deck of one sailing vessel to the next. By 1907, he was an old man who would retire soon. When he was gone, there would only be ghosts, and even they would disappear as the city turned its back on the river and its past.

Conners had come with his parents from Ireland at the age of two. As a youth, he saw the river, the logs and the men in red shirts and calk boots, and he did some calculating. He and his brothers knew they could make a good living if they worked hard and took some risks. William began as a wedge boy, knocking together huge rafts of logs to float downriver to the Bangor Boom, the last collecting point at the end of a series of booms beginning north of Old Town. He advanced rapidly to camp boss in the woods, where the trees were felled, and from there to boss river driver.

Conners's obituary in the June 21, 1921 *Bangor Daily News* read:

> *While there were many expert drivers and rafters in Bangor and all along the river for miles above, William Conners and his three brothers, John, Edward and Patrick, early gained distinction as fast and hard workers, afraid of nothing, knowing all the ways of the river and details of the business, and each of them having the knack of getting the best service out of a crew and keeping the men contented.*

Conners lumbered with the famous John Ross, the boss on the West Branch drive and the man who led a legendary expedition of Bangor Tigers in 1876 to drive logs down the Connecticut River from its headwaters to Hartford. Conners was also in the shipping business with fellow Irishmen Timothy Field and James O'Donahue, both of whom got rich mining quartz in California. All three men had vessels in the West India trade named after them.

The Bangor Boom was an important link in the Queen City's lumber economy. In 1885, the season began on May 15 and ended on November 3. Thirty men were employed driving in from the Penobscot Boom (the collection of booms north of Old Town) and forty more in rafting and running at the Bangor Boom. The distance from Argyle to Bangor was sixteen miles, and it required about eight days to bring down one of the rafts. Several dams had to be passed, reported the *Bangor Daily Commercial* on January 18, 1886. The workers included drivers, rafters and pilots. In the early days, the rafts were propelled by scull oarsmen, and later they were hauled effortlessly by little steamers, one of which was named after Conners.

Navigating huge rafts of logs or lumber over dams or through the rapids could be dangerous, according to David C. Smith in his book *Lumbering in Maine, 1861–1960*, so it was no wonder that Conners had charge of the work for so long. Besides needing to be one step ahead of disaster—like the year

the boom broke and logs drifted all the way to Bucksport—political agility was required, too.

One year, Conners threatened to use force if the city didn't prevent the dumping of sawdust, bark and other debris that clogged the boom into the river. There were battles with Great Northern Paper over control of the river drives and efforts to get the city to build a more commodious slip for rafting over its new dam at the waterworks.

Conners was politically savvy and active in Irish-American causes, as well. An "old-time Democrat," he served on the Bangor City Council, as well as two terms in the legislature, after he retired in 1909.

Near the end of his life, clever reporters concocted numbers to measure Conners's greatness. He had handled not fewer than four billion feet of logs at the Bangor Boom, they said. "At the lowest estimate, the logs rafted and driven by William Conners would, if placed end to end, make a girdle of spruce, pine and hemlock four times around the world and leave enough over to build a big city," reported the *Commercial* on May 26, 1921, shortly before his death.

The numbers often varied, but the writers' intent did not. Conners's career was a memorial. That amount of logs would never pass through Bangor again. Lumber shipments had dropped more than 80 percent since the peak in 1872; so had the number of vessels clearing the port. "A sailor would be a stranger there now," said the *Bangor Daily News* in 1921. So would men like William Conners, log king of the Penobscot.

Fred Ayer and Eastern Manufacturing

February 25, 2008

The Eastern Manufacturing Company in South Brewer was the biggest employer in the Bangor area a century ago. Its modern sawmill, reputed to be the largest in Maine, and its pulp and paper mill dominated the waterfront across the Penobscot River from Bangor. The company's president and founder, Fred W. Ayer, one of the state's top industrialists, was a legendary character, one of the last links to the area's glory days as a lumbering capital.

When Eastern Manufacturing Company's pulp and paper mill slowed production and then closed for a couple of months at the end of 1907 and the beginning of 1908, it was a major economic blow to the area. The *Bangor Daily Commercial* reported that "700 or 800" residents of South Brewer worked there. Their labors were the chief means of support for two thousand people.

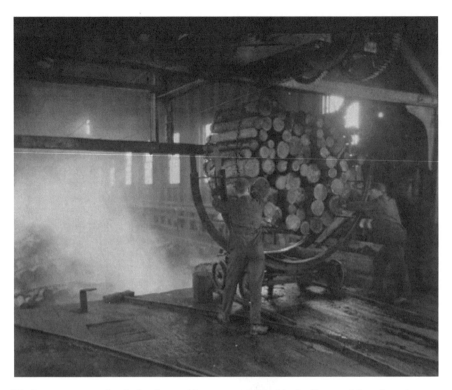

Workers transport a load of pulpwood logs to a pond inside the Eastern Manufacturing Company mill. *Courtesy of the Maine Folklife Center, University of Maine.*

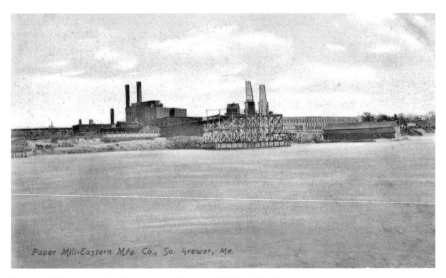

Eastern Manufacturing Company. *Courtesy of Richard R. Shaw.*

Part of the paper mill cut back production in December because of the economic depression associated with the Panic of 1907. Then, in January, the entire plant closed when its electrical supply was switched off by the Bodwell Water Power Company, which was shorted out by its own economic problems. The *Bangor Daily Commercial* reported "great rejoicing" when the mill reopened on February 17. The company had recently secured a contract to manufacture "a superior grade of writing and office paper" for the federal government. A great future was expected.

The previous spring, on May 31, the *Commercial* had presented readers with a feature headlined "The Immense Industrial Plant at South Brewer." The story was immense as well, filling most of a page. "It is doubtful if more than a comparatively few people in this section realize the enormous business that is being done at Eastern Manufacturing Company," wrote the awe-struck reporter.

The property extended for a mile along the waterfront from the Stetson Ice House to the Sedgeunkedunk Stream. The plant covered twenty acres, and a much greater area was filled by immense piles of wood. Logs were towed from the Bangor Boom to Dyer's Cove at the upper end of the property for storage. The wharves near the sawmill were piled high with lumber. In warm weather, a fleet of vessels was constantly loading.

No more trees had to be cut down than necessary because of this mill, declared the reporter. Nothing was wasted.

> *The saw gets all that is good for lumber. The bark, sawdust and smaller waste is used for fuel to generate steam to operate some other parts of the plant* [although electricity was gradually replacing steam power]. *The edgings are used for fuel and the slabs and larger edgings go to the pulp mill where they are made into pulp.*

Ayer had purchased the property, which was known as the old Palmer Mill, in 1881, said the *Commercial*. He operated it as F.W. Ayer and Company until 1901, when he sold it to the Eastern Manufacturing Company, remaining as company president. The pulp mill was built in 1890 and the first of several paper mills in 1896.

"Ayer's mill was a marvel," David C. Smith noted in his history of Maine lumbering. Ayer was known as an innovator. He introduced the first band saw, "the wonder of the age," in the Penobscot area. Mill men came from as far away as New Brunswick and New Hampshire to see the new miracle saw demonstrated. It was said to have set a new world record.

Ayer was also an aggressive capitalist. In the early 1890s, he had tried with only limited success to corner the Penobscot log market. Later, he played a major role in the battle with the Great Northern Paper Company for control of the log drives in the Penobscot.

Ayer was a complex man who worked hard and played hard. His obituary in the *Bangor Daily News* on September 28, 1936, read:

> *His interests were as intense as they were varied. He made a profession of his sports and hobbies and brought to his business the thrilling gamble of sports. The quality which most strongly marked Mr. Ayer's attitude toward his passionate interests was the will to excel.*

One of his passionate interests that he raised almost to the level of a profession was stamp collecting. His accomplishments in that field were so well known that he was invited to England to meet with the Duke of York, the future King George V, who was also an avid stamp collector. After they spent an afternoon conversing, the duke bought his collection.

Ayer also did what was expected of upper-crust Bangor males. He joined exclusive clubs, including the Knickerbocker Whist Club of New York and the Algonquin Club of Boston, as well as the Tarratine Club in Bangor. He was a noted sportsman. The *New York Times* reported on April 1, 1900, that he caught "with the fly" five hundred pounds of salmon in one season at the Bangor salmon pool. His obituary suggests that he invented fly-fishing at the pool.

Ayer was a noted yachtsman. On August 10, 1902, the *New York Times* reported the launching of his ninety-foot steam yacht *Helena*. It was built in its entirety on the premises of the Eastern Manufacturing Company, with the hull and engines designed by Charles B. Clark, one of the company's executives.

Ayer loved speed and power on the water, as well as in the mill. During the summer of 1907, the *Bangor Daily News* noted that five hundred people lined the banks of the Penobscot River to watch a race between the *Helena*'s tender and another motorboat.

Ayer was connected to the living past a century ago, but he was always trying to leap into the future. While that particular past has receded a bit since then—and it no longer lives for most Bangoreans—it was Fred Ayer and all those like him, noted for their "wide scope, initiative and daring," who built the base upon which Bangor rests today.

BANGOREANS LOVED ICE

December 26, 2005

Ice! The word caused excitement that is hard to imagine today. When ice hardened the Penobscot River each winter, it changed the lives of thousands. Bangor's two daily newspapers covered this annual event in as great detail as they covered politics and crime.

First came the promise of money. Before electric refrigeration was widespread, people kept perishable goods cool by buying blocks of ice for their iceboxes. It was a profitable business.

"Ice Industry to Boom Again?" asked a headline in the *Bangor Daily News* on October 2, 1905, when balmy autumn weather still held sway. The top officials of the American Ice Company had come to town asking a lot of questions and looking over the area's icehouses. Before the big trust took over most of the ice industry in the Northeast in the 1890s, business had

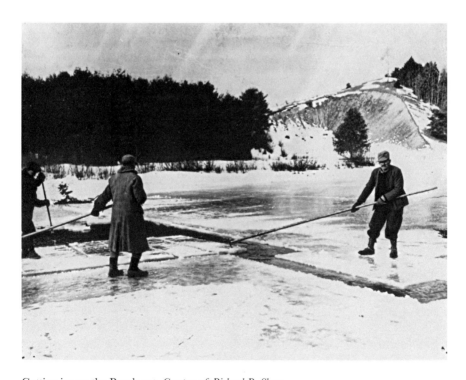

Cutting ice on the Penobscot. *Courtesy of Richard R. Shaw.*

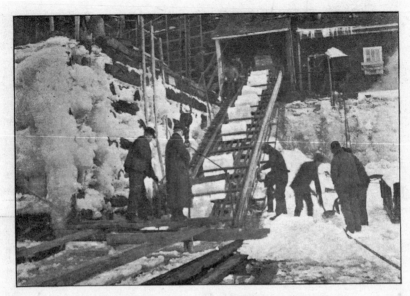

HARVESTING ICE ON THE PENOBSCOT, BANGOR, ME.

Loading harvested ice into a storage house at Bangor. *Courtesy of Richard R. Shaw.*

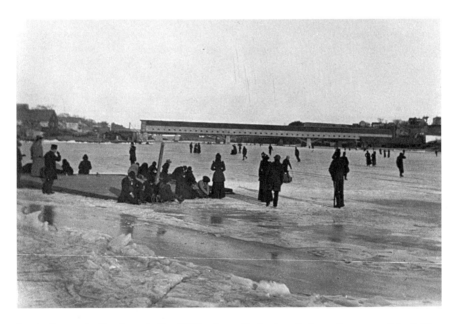

Ice-skating on the Penobscot before 1902, when a freshet knocked out the center of the bridge between Bangor and Brewer (background). *Courtesy of the Bangor Museum and History Center.*

boomed along the Kennebec and, to a lesser degree, the Penobscot Rivers as many independent companies competed. Hundreds of day laborers and farmers with teams and wagons had been able to make some extra income to help get their families through the winter.

The American Ice Company curtailed production of Maine ice to what it needed after it ran out of Hudson River ice and the "artificial ice" it manufactured. In the early years of the twentieth century, hardly any ice was harvested along the Penobscot, compared to the half million tons in 1890, back when Maine ships carried Maine ice to Cuba and beyond.

But things seemed to be looking up at the end of 1905. The American Ice Company was predicting that it would harvest seventy thousand tons, or about one-eighth of its Maine ice, from the Penobscot. Most of the rest of the ice would come from the Kennebec River, along with a small quantity of pond ice from Boothbay, according to the December 23 *Bangor Daily Commercial*. Of course, everything depended on the weather in New York and Maine.

As the autumn wore on and the air got colder, the newspapers examined another big question: when would Bangor's harbor be iced in? No captain wanted to be trapped in the ice. Back then, the Penobscot was an important trade artery. Hundreds of vessels carried lumber from Bangor and delivered coal and other needed goods to the Queen City. Travelers depended on the steamboats that visited the city and nearby towns.

Most sawmills in the area stopped operations during the last week in November, "as the ice is getting thick where the logs float," reported the *BDN*. A skim of ice covered the river from bank to bank a few days later, but the little Bon Ton ferry, which shuttled people back and forth between Bangor and Brewer, was able to break a channel.

On December 13, the last Boston boat of the year, the big, rugged steamer *Penobscot*, arrived preceded by a tug. A watch was stationed in the pilot house all night, and both pilots and quartermasters were aboard "ready to start down the river if ice began making too fast." The harbor was closed to navigation the next day. A traveler would have to go to Winterport or Bucksport to catch a steamboat or else take the train.

The temperature registered twenty-three degrees below zero at the Bangor Railway & Electric Company's power station in Veazie on December 15. Two weeks later, however, things warmed up, much to everyone's chagrin, causing the river to clear all the way up to Stern's mill at East Hampden. Nevertheless, area people were going ahead with their plans to have some winter fun.

"Frozen water everywhere and not a place to skate," complained the *Bangor Daily Commercial* on January 2. But people were finding places to skate near the

ferry way and above Stern's mill, where they trekked on the trolley cars. The surface was sometimes rough, and sometimes the ice was unsafe, as sixteen-year-old Alice Manley of Brewer found out when she fell through by Stetson's railway and had to be rescued by ten-year-old Ralph Bridges. Iceboats were also in evidence on the river and area lakes, as were "ice chairs" in which "men cottagers had the pleasure of sliding their wives and daughters over the lake all day." The ice fishing season opened on February 1.

While the river may have been having trouble holding onto its ice cover, there was plenty on hilly Cedar Street, one of Bangor's favorite coasting spots. "The rut in which people travel is clear ice from Fifth Street to Second and remarkable time is being made," stated a *BDN* reporter on January 8. Many people on big sleds got going so fast that they had to "tumble into the ditch" as they peaked the hill at Second Street to avoid tearing down into Main Street, where the trolleys ran.

The area's many horsemen were also taking advantage of conditions. They were out late in December racing their steeds in the snow up and down the Hampden road between Wood & Bishop Company at 329–39 Main Street and the poor farm. By January 8, an ice track had been opened on the river above the dam. Sixty rigs were out on Sunday, and hundreds of onlookers lined the shores admiring "the good old nags." The Gentlemen's Driving Club would soon open its own track below the dam when the ice hardened up.

Spring was still months away. Ice in the spring sometimes had a malevolent face about which few people liked to think. It could become violent, as it had in 1902, when big floes and logs pushed along by the swollen river knocked out two important parts of the city's infrastructure, the covered toll bridge and the nearby railroad bridge to Brewer. Of course, Penobscot River folk were hardly thinking about such possibilities so early in the winter. They were too busy sharpening their ice saws and their skates.

THE NEW BANGOREANS

IMMIGRANT TENSIONS

October 15, 2007

Thousands of immigrants streamed into Maine looking for work a century ago. Approximately 40 percent of the residents of Bangor were either foreign born or the children of foreigners, according to the 1910 census. The number increased when transient loggers and sailors came to town. This influx of foreigners, many of whom spoke little English, created tensions reflected in the newspapers of the era.

Sometimes the conflicts in Bangor and in nearby cities were among the immigrants themselves. "Will Waterville Have a Race War?" read a headline in the *Bangor Daily News* on August 15, 1907. "Syrians and Greeks Appear to Have Tribal Hatred for One Another," it continued. On September 2, another headline announced that the French and Greeks were brawling in Manchester, New Hampshire. Meanwhile, numerous stories reported bloody fights—sometimes murders—among Italians. Brawls between ethnic groups were a frequent feature in the Hancock Street area of Bangor, near the saloon district, where many of the new immigrants lived.

More often than not, however, cultural differences pitted native Mainers against newcomers in a movement that would culminate in the brief rise of the Ku Klux Klan in Maine in the 1920s. While employers wanted inexpensive immigrant labor, the average Mainer viewed many of the newcomers with fear and contempt.

Many immigrants worked as peddlers before setting up their own stores. *Courtesy of the Bangor Public Library.*

Logging contractors hired barely qualified immigrants to work in the woods. Ethnic stereotyping resulted. "Not Good Lumbermen," declared a headline in the *Commercial* on November 16, 1907. "Italians as a rule do not make good in the great Maine woods." The men who had "made good" building railroads and cutting granite did not seem to know how to cut down trees properly.

Sometimes misunderstandings about work conditions turned into crimes, as two Poles, Peter Poulskaw and Nicholas Eilandy, discovered. Neither man spoke English. They accepted cash to get to their new jobs at a logging camp, which they had been led to believe was only 3.5 miles from Kingman. After arriving in Kingman by train, the defendants said that through an interpreter they were told the camp was really 35 miles away, reported the *Bangor Daily News* on August 9. "They expected to walk this distance and not relishing the idea had vamoosed," the newspaper claimed. Perhaps they did not realize a wagon would be sent.

The two were sentenced to fifteen days in jail under Maine's "peonage law." The law was repealed in 1917 after the U.S. Supreme Court declared a similar law in another state unconstitutional, according to Charles A.

Scontras, historian for the Bureau of Labor Education at the University of Maine. By then, 342 men had been jailed, even though their "crimes" often had as much to do with the misrepresentations of hiring agents as they did with their behavior.

Native contempt for foreigners was particularly evident in harsh newspaper stories about a band of about two dozen "gypsies" who arrived in September of 1907 looking for a place to live. They became the center of an interested crowd as they camped out temporarily in Union Station. "The newly arrived Bangoreans claimed to be Arabs...but those who took a look Tuesday think they are the usual wandering gypsies," reported a *Commercial* story on September 17. "The costumes of the different members were very picturesque and some of the women's gowns would make Worth of Paris green with jealousy."

By October 1, the story's tone had taken a dark turn when a reporter and photographer from the *Bangor Daily News* visited these "gypsies" at their new home in East Hampden, just outside of Bangor. The group, now referred to as "Hungarian coppersmiths...masquerading as a band of gypsies," had pitched four large tents in a field near Stern's lumber mill about one hundred yards from the trolley tracks.

"There is nothing picturesque about the crowd," growled the reporter. "The one element that sticks above all others is dirt. Dress, what there is of it, consists of faded rags, that were perhaps once gaudy."

Their Hampden neighbors did not seem particularly worried, and the men were busy all day making fine copper kettles that sold well, related the reporter. But they were "fierce looking customers," and when the news team asked to take a group photograph, they were ordered to pay $4—worth nearly $100 today—or leave. As they tramped back across the field, the angry reporter sputtered, "From the filth and the jargon, it was blissful to look across the good Hampden fields to trim white farm houses; to drop the breath of Europe, and get into our own good Maine atmosphere. White men are white men."

This sort of chauvinism had been condemned in an insightful editorial two months earlier in the same newspaper. The editorial writer had pointed out on July 18 how each new group of immigrants was condemned by the one before it. "Pride of race" was "the most silly kind of pride going." The writer continued:

> *There are men still active in Bangor today who can remember the time when a person of Irish blood was a social outcast. The...sanctimonious Yankee overlords had only slightly more respect for the Irishman whom he hired than*

did the southern slaveholder for his black chattels. Since then the Italian has taken the place of the Irishman in performing the outdoor drudgery, and the white-faced Swedish girl has become the maid of all work in the house, while the small trader and the peddler is no longer an Irishman, but a Jew or an Armenian…has the emancipated Irishman profited as he should by his trying experience?…are not the citizens of Irish blood in Bangor today as bitter against Italians, the negroes and the Armenians as were the Yankees against the Irish half a century ago? This habit of condemning strangers without trial and the other habit of looking with suspicion upon all who do not follow our individual examples are both dangerous.

ITALIANS BUILT RAILROADS, MILLS, DAMS AND MORE

May 9, 2005

Maine was rife with labor strife a century ago, much like the rest of the nation. Strikes were a common occurrence as workers demanded a shorter workday and more pay. Socialism seemed to many to be a viable alternative to capitalism.

To complicate matters, Maine was already failing to keep up with the rest of the nation in population and industrial output. There weren't enough natives to do the work, and many weren't willing to do what was necessary under the often poor work conditions and for low wages.

Onto this stage marched thousands of Italian immigrants over a period of approximately thirty-five years after 1880. In Maine, they played an especially important role in building the railroads and the paper mills and in mining the granite and other stone that would go into buildings and monuments around the nation.

In April 1905, a thousand or more of them had gathered in tent cities between LaGrange and Stockton Springs through the outskirts of Bangor to build the Northern Maine Seaport Railroad, a branch of the Bangor & Aroostook. Even though this was not the first time large groups of Italians had worked in Eastern Maine, their arrival set off a wave of curiosity and not a little apprehension.

"They are on the whole law abiding and few if any complaints have been made against any one of them," reported a writer for the *Waldo County Commercial*. "They seem to be as happy and contented as our American workmen and feel entirely at home so long as they have their chunk of bread and their bottle of beer."

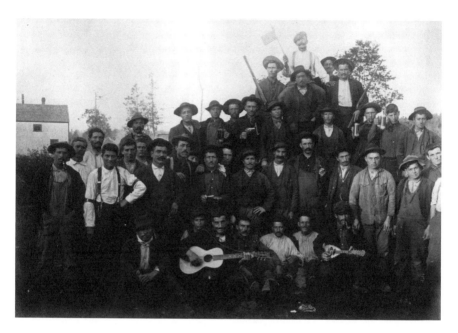

These Italian immigrants worked on the Bangor & Aroostook Railroad's Medford Cutoff between South LaGrange and Packards, near the head of Seboeis Lake. *Courtesy of the Fogler Library Special Collections, University of Maine.*

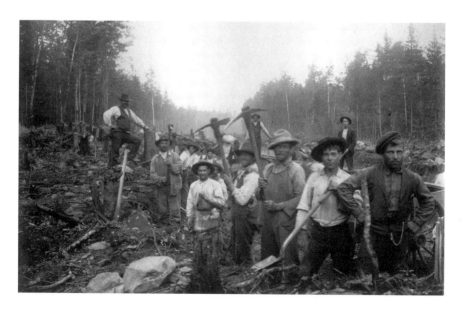

Italian immigrants who built the Bangor & Aroostook Railroad's Medford Cutoff. *Courtesy of the Fogler Library Special Collections, University of Maine.*

The Italians caused suspicion in some quarters, however. Their arrival set off tough talk, for instance, at the Bangor Police Station, where a new chief was being fêted one April afternoon. One of the gifts Chief T. Herbert White received was a new revolver.

"The revolver is of gun metal, highly burnished, and is about the handsomest weapon that has ever decorated the hip of a chief," wrote a reporter for the *Bangor Daily News*. Then he added, "It will be handy when the 'Dagos' out on the new railroad commence to get busy with the peace of the community."

My dictionary defines "dago" as offensive slang, an alteration of the Spanish name Diego, used as a disparaging term for Italians, Spaniards or Portuguese. It would have no place in a newspaper today, but it was common parlance a century ago, just as ethnic slurs like "paddy" and "mick" had been a few decades previously when referring to the Irish.

References to the labor tensions that contributed to this enmity can easily be found by reading a few weeks' worth of newspapers from back then. Italian laborers were striking in Calais at a paper plant construction project, and a short time later some arrived to fill the jobs of striking lime kiln workers in Rockland. They were not only unafraid to speak up for their rights, but also, on occasion, were willing to take the jobs of other workers, making them the object of suspicion by both employers and unions.

These were the sorts of events that elevated tensions, helping to account for the ugly incident that occurred in Bangor between Italians and police in May 1905, after a falling out over working conditions on the Northern Maine Seaport Railroad.

"Dago Invasion Tuesday Noon," declared an obstreperous headline in the *BDN* on May 3. The steamer *City of Rockland* had brought 175 more Italian laborers to the Queen City to help build the new railroad. At the dock,

> the atmosphere was brilliant with red handkerchiefs and caps and had a wonderful flavor of garlic and onions...There were extension cases and wooden boxes and shiny black trunks with tin bands about them. There were musical instruments galore and a cartload of bric-a-brac.

Three days later, another headline—"Stranded Dagos Look for Help" —announced that many of the workers were back in Bangor. They had been sent to nearby Hermon, where, instead of the "grading" they thought they had been hired to do, they were ordered to work in ditches in water up to their waists. They came to Bangor City Hall asking for food and transportation back to New York City.

The rumpus that occurred involved the police, the overseers of the poor, a labor contractor and some construction bosses. After an unsuccessful search for the labor contractor's local representative, who had brought them to the area, the hungry workers were given a barrel of crackers and "half a cheese" and allowed to sleep in the attic of city hall overnight.

That evening, the police interviewed bosses from the Hermon camp and a Mr. Clement, the local representative for one Marco, the New York labor contractor. A *BDN* reporter summed up what the trio had to say: "The dagos are a bad lot…They growled the minute they came into camp…and they are now simply trying to 'work' the city for their fares back to New York."

Clement reportedly said:

> *All this talk about working in water is pure bosh…Two days before they came it rained and one of the ditches filled. When they began to work they began to jabber like a lot of boobies and finally a delegation reported that they couldn't stand it. I set eight men to work bailing out—then they wanted rubber boots and more pay…They kicked at this and they kicked at that and the other. We couldn't suit them.*

He added that, even as they spoke, twenty-seven more disgruntled workers were on the road from Hermon to Bangor.

As for the Italians' side of the story, it is largely lost. Their words about the water in the ditches are reported briefly and in broken English, as if to entertain rather than to inform Bangor readers. Indeed, their appearance and habits were more often than not reported with amusement and contempt in the local newspapers.

The last story in this newspaper trilogy was brief. The *Bangor Daily News* headline announced, "Dagos Hiked: Police Said 'Scat!' Yesterday Morning and They Scattered."

"Now you get out of here and don't you stop, even if you have to walk back to New York," commanded Deputy Police Chief O'Donohue, pointing to the door. Some of the workers returned to work. Others, having found some money, took the train back to New York, while still others boarded the steamboat to Boston.

"Chief White says that he isn't going to fool with the Italians a minute this summer. They must toe the mark or take the consequences," a reporter wrote.

The chief may have been referring to previous incidents, like the one in 1887 in Bangor in which fifty-eight laborers were housed and fed in the

Bangor almshouse after "terrorizing" inhabitants along a one-hundred-mile route as they walked from somewhere on the Canadian-Pacific Railroad after a job fell through. At one point, it appeared to locals that they were going to try to board a steamboat by force in order to get passage back to New York.

This would not be the end of labor woes for the Northern Maine Seaport Railroad. Two more walkouts, on sections of the road near Hudson and Stockton Springs, were reported in the *Bangor Daily News* on May 19. Construction was reportedly behind schedule, and rumor had it that the head contractor had gotten after his subordinates "with a sharp stick."

In the end, however, the Italians would finish the railroad as they had several others in Maine, and then most of them would head back to Boston or New York City. Many saved their pay and eventually returned to Italy.

Their work was judged to be of high quality. The friction between the new immigrants and the old was forgotten, and today parts of the railroads and some of the paper mills—what remains of them—are a monument to their efforts.

NARCISSUS A. MATHEAS, AFRICAN AMERICAN ENTREPRENEUR

April 23, 2007

Narcissus A. Matheas sailed up the Penobscot River to Bangor in 1834, when he was just sixteen. Back then, Bangor was a boomtown, a capitalistic oasis and polylingual crossroads for all manner of ambitious men and women from every corner of the world.

Thirty-six years later, Narcissus sailed back down the river. He had made enough money to spend the rest of his life as "a man of consequence." By the time he died many years after his departure, he had become a legend in the Queen City, a symbol of "Old Bangor"—that golden lumber town of misty memory before electric light bulbs and gasoline engines.

"Old Bangor Remembers Him" declared a *Bangor Daily News* headline on March 30, 1907, over a large photograph of Matheas. "Death of Narcissus A. Matheas, Who Was a Famous Hackman and Fireman Here Before the War." The photograph is of a man with a shrewd and energetic squint, curly hair and a beard tinged white, high cheekbones and black skin. He and his wife were the parents of one of Bangor's first African American families.

Matheas was from Saint Antoine in the Cape Verde Islands, then a Portuguese colony off West Africa. He was "a colored man of the progressive

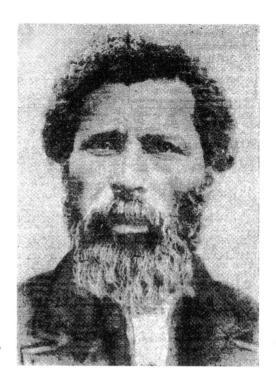

Narcissus A. Matheas. *Courtesy of the* Bangor Daily News.

sort, who coming in youth from the African tropics entered with great energy into American life and made a comfortable fortune here in Bangor," said the newspaper story.

> *He received a fair education in the Apprentice school here, and afterward, through the assistance of friends and by his own industry and business ability, got along very well in the world.*
>
> *At one time he had seven job wagons engaged in trucking and the transfer of baggage about the city, and enjoyed a practical monopoly of that business for years. He also owned and drove the first coach—a nine-seater—ever owned by a private individual in Bangor, was the first man to deliver ice to customers here and also the first to deliver express packages.*

For many years, his wagons stood in West Market Square. He was commonly seen at the steamboat landings waiting for passengers.

Part of Matheas's fame rested on his heroics as a firefighter. Competing fire companies raced one another to fires. According to the newspaper:

From 1852 to 1856, Mr. Matheas was a member of the Bangor fire department, and his horses were always ready to haul the famous old hand engine, Eagle 3, to which he belonged, and in whose hot rivalry with Tiger 6 for "first water" he was always active. Stories by the yard could be told of the races between the Eagles and the Tigers—and the fierce combats too, between those famous companies.

Matheas had another side as well. He was a quiet, genial and peace-loving man. He was honest and generous, cheerful and kindly. These were the characteristics that made him popular and successful as a businessman and a citizen. For nineteen years, he was also sexton of the Hammond Street Church.

Matheas accumulated a considerable amount of property, and he was looking forward to returning to Cape Verde. A disastrous incident delayed him, however.

In 1862, the Portuguese brig *Jovan Arthur*, loaded with pine lumber, was wrecked in the Penobscot when its crew attempted to take it downriver under sail instead of being towed. Matheas bought the wreck with the idea of having it repaired so he could sail back to Cape Verde in his own vessel. He underestimated the cost and had to abandon the plan after losing a great deal of money.

Eight years later, in 1870, however, he was able to cross the ocean to the island nation with his wife and two of his children.

In the fertile island of Saint Antoine, the old-time Bangor hackman lived comfortably the rest of his days, returning once in 1892, to spend a year in Bangor with his son Fred. In Saint Antoine he was a man of consequence, having a plantation on which he raised fine crops of coffee and other crops that flourish in the balmy garden of the sea.

He died on February 16, 1907, at age eighty-eight.

Our interest in the family does not end there. Matheas's wife died in 1904. The couple had four children—Joseph, Frank, Fred and Lucretia. Lucretia had returned to Cape Verde, married and died by 1907. The three sons lived in the United States. Joseph was an upholsterer in Camden, New Jersey. Frank lived in Philadelphia. Fred had remained in Bangor, where he was in the trucking and furniture-moving business and a famous fireman like his father. "For years his huge moving van with its strikingly original legends has been a famous Bangor institution," said a story about Fred's death in the *Bangor Daily News* on June 8, 1912. There is no mention of his parents.

For a time, Fred had worked with his brother Frank and Frank's son Fred W., according to Maureen Elgersman Lee in her book *Black Bangor: African Americans in a Maine Community, 1880–1950*. Frank's son, whose full name was Frederico Walter "Dick" Matheas, graduated from the University of Maine (UM) with a degree in civil engineering in 1907. He was probably UM's first African American graduate, according to Gerald E. Talbot and H.H. Price in their book *Maine's Visible Black History*. Fred W. was an athletic star at Bangor High School and the University of Maine. He had a long career in Philadelphia city government, becoming assistant director of public safety.

Narcissus A. Matheas is not mentioned by Talbot and Price or by Lee. A century ago, only "Old Bangor" remembered him, and then he was forgotten until today.

Bangor Irish Worked Hard and Profited

March 13, 2006

The loyal followers of the Ancient Order of Hibernians hung an Irish flag out the window of their Bangor headquarters on St. Patrick's Day 1906. Mostly old and graying, they turned out to hear Samuel B. Rogers sing "Come Back to Erin" and Cornelius O'Brien render up "I'm Glad I'm an Irishman's Son." At the end of the program, however, these veterans of hardship paid homage to their adopted country with a hearty chorus of "The Star-Spangled Banner."

No parade was held that year, as there had been in the past when ties were a little stronger with the homeland. But the *Bangor Daily Commercial*, the voice of the Democratic Party, which included most Irish voters, reported:

> *There will be no mistaking this day for every loyal member of the Irish race will show his devotion to the memory of the man who did so much for the Irish race by wearing something of green on his person, whether it be a sprig of shamrock in his buttonhole, or a bit of ribbon.*

Times had changed for the better since thousands of starving, impoverished Irish had established a tenuous foothold in the Queen City and other cities up and down the eastern seaboard. They had survived efforts by Yankee sailors to burn them out in the 1830s and all the discrimination, threats and ridicule that had followed that event for decades afterward. Those days

were over (although the anti-Catholic Ku Klux Klan would make a brief appearance in Maine in the 1920s).

The Democratic Party had recently taken over city government for the second time in modern history. Men named McCarthy, Crowley, Sullivan, Grady, Doran, O'Leary and Fleming sat on the city council. Irish Democrats had made a clean sweep in three of the city's seven wards and helped elect powerful aldermen in two others, thanks to alliances with a few influential individuals like Charles L. Snow, the president of the Snow & Nealley Company and a Democrat.

The city's Republican newspaper, the *Bangor Daily News*, held no grudges. It ran an editorial praising St. Patrick and several more recent celebrities of the Emerald Isle. A few months earlier, in an editorial condemning ethnic slurs, the paper had stated that anti-Irish words like "paddy" and "mick" were now mainly humorous references used among Irishmen themselves.

Many Irish were doing better economically, as well as politically. The city treasurer was a Brennan, and the clerk of the common council was a Donovan. The school agent and inspector of buildings was a McCarthy and the superintendent of sewers a Grady.

They had virtually taken over the police department. Men named O'Donahue, Fahey, Knaide, Donovan, O'Leary, Mackie, Reagan, Crowley, Finnigan, McNamara, Kennedy and Curran, to name a few, were walking the beats. And they heavily populated the fire department—O'Brian, Curran, O'Leary, Mooney, Rogan, Sullivan, Crowley, Finnigan, Moriarty and others.

Many had done well in the private sector. A quick perusal of the city directory showed several lawyers—Dolan, Gillin, Grady and Laughlin—and a few physicians, Drs. Hennessy, Brooks, McCann, Murphy and others.

Many excelled at music, especially the Connors—Ella Connor, Katherine Connor, Lena Connors and Etta J. O'Connor were among the Irish music teachers.

Irish merchants were in abundance. You could buy art supplies from J.F. Gerrity & Co., awnings from the Mulvany Bros., ice cream freezers from James Mooney & Co. and hats from Mrs. S.A. Moran. There were any number of Irish grocers, starting at one end of the alphabet with J.H. Brennan at 1 Birch Street and ending with Mrs. L.C. Toole at 335 Hancock Street.

Irish contractors and skilled craftsmen of all sorts employed Irish workers, who in turn joined the city's more than two dozen labor unions. The Grady Construction Co. at 49 Hammond Street and A.H. McVarish at 146 French

Street were among them. E.F. Kelley & Son installed plumbing, T.E. Quinn & Co. put on roofs and J.E. Kennedy put in hot water heating. Andrew Kelley built and repaired carriages, while M. Lynch & Co. hung bells. The list was much longer.

"At the turn of the century, the Irish in Bangor maintained a position of mutual accommodation in the social and political structure of the Protestant city," wrote Judith S. Goldstein in her book, *Crossing Lines: Histories of Jews and Gentiles in Three Communities.* That meant that Protestants and Catholics got together when they shared goals, but there were still barriers. And it meant that prominent Protestant leaders turned out for special Catholic events, like the fiftieth anniversary of the founding of St. John's Catholic Church in 1906.

Goldstein continued:

> *The whole city celebrated the growth of the Catholic community: the building of the church in 1856; the addition of twenty beautiful stained glass windows in the 1880s; the installation of the bell that tolled over the river front; and the establishment of religious schools and residences. No one recalled, however, that anti-Catholic feelings had prevented St. John's from building a school on Broadway in the 1840s. Nor was mention made of the strong strains of social superiority that Bangor's Protestant community harbored decade after decade. Catholics held a conspicuous but separate place in the city.*

The Irish had made tremendous progress, but French Canadians, Italians, Jews and other newcomers continued to struggle to gain acceptance.

TRAINS, BOATS AND AUTOMOBILES

JOHN R. GRAHAM MADE THE TROLLEYS RUN ON TIME

April 25, 2005

John R. Graham was the man who made the electric trains run on time in Bangor. A century ago, the Scotch-Irish immigrant created a utility empire out of financial chaos.

The *Bangor Daily News* called him a wizard just three years after he arrived in the Queen City. When he died suddenly, after living here only thirteen years, the paper said he had "benefitted Bangor beyond calculation." Yet today he is almost forgotten, unless you attend the John R. Graham School in Veazie or work in the Graham Building at Harlow and Central Streets in Bangor.

At the turn of the last century, most people couldn't afford a horse, and automobiles were still an expensive novelty. But for loose change you could ride the electric street railway—the trolley or "the cars" as it was called —from Hampden through Bangor and as far north as Old Town, west to Charleston or east across the river to Brewer.

The first electric street railway in New England—the second in the nation, as it was said to be—was created in 1889 in Bangor by F.M. Laughton and F.H. Clergue. An awed newspaper reporter covering the inaugural event said the new mode of transportation ranked with the seven wonders of the world.

The system, however, barely had enough power to push its cars up hills. That's why a new power station in Veazie was opened in 1891. It was one of

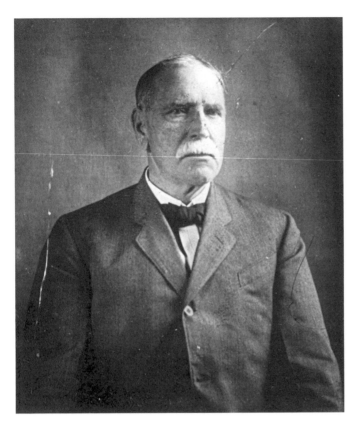

Left: John R. Graham. *Courtesy of the Bangor Museum and History Center.*

Below: Trolleys and horse-drawn vehicles shared Bangor's dirt streets. *Courtesy of Richard R. Shaw.*

the first successful attempts at the transmission of electricity in the United States, according to Edward M. Graham, John's son and president of Bangor Hydro-Electric Company for many years.

By 1900, the trolley company's hydroelectric station in Veazie was powering over thirty miles of railway, about ten thousand incandescent electric lamps and nearly one hundred horsepower in small motors.

Use of electricity for light and power was still a novelty for homeowners and most businesses, but the electric trolley had become a fixture that changed many people's lives. Before Christmas 1904, the Public Works Company was handing out lottery tickets on its cars—the winners got discounts to have their homes wired!

The men who created the system were more visionaries than businessmen, however. A hodgepodge of small railway, electric and water companies, doing business under different financial arrangements, operated under the management of the Public Works Company. It was heavily in debt by the time John R. Graham arrived on the scene in 1902. He had been sent by the General Electric (GE) Company, which had a large financial stake in the Bangor utilities, to see if something could be done to put them on a firm financial footing.

Born in Northern Ireland in 1847, Graham grew up in poverty in Boston. He became a successful shoe manufacturer in Quincy, Massachusetts. Approaching middle age, he became interested in real estate development, especially in derelict properties that nobody else wanted. Failing electric street railways became his specialty.

After rescuing the Quincy and Boston Street Railway, his work became widely known, and GE asked him to make the trip to Bangor. He was so impressed by what he saw that he decided to stay.

GE made him the general manager and treasurer of the Public Works Company, which consisted of more than a half dozen entities, including the Bangor Street Railway, the Old Town Electric Light and Power Company, the Penobscot Water and Power Company and the Brewer Water Company. It also included the Bangor, Orono & Old Town Railway, the Bangor & Northern and the Bangor, Hampden and Winterport.

A century ago this month (April), Graham got some funding together and reorganized the whole operation.

"Public Works Co. Will Die Tonight," stated a headline in the *Bangor Daily News* on April 6, 1905. "And in its Place Will Rise the Bangor Railway and Electric Company." Most of the entities operating under the aegis of the Public Works Company were consolidated into the new company either then or within the next couple of years. The article continued:

At its head will be John R. Graham, the wizard, whose touch has in three years raked and shaken and imbued life and developed all those different members until they form one great body. Mr. Graham has done business on a large scale—on a great scale—and it is for that reason that Friday will see the organization of one of the greatest companies in the New England States controlling public utilities.

The story went on to describe the charismatic Graham in his office, where "he was just as genial and happy as ever—bubbling magnetism from every pore."

He showed the reporter a list of plans written in pencil on a sheet of paper. Some of those plans the reporter was not allowed to write about, but he could tell his readers that Mr. Graham was planning to build a new "car barn," and he hoped to extend the Hampden tracks from the Lower Corner to Dorothea Dix Park. Graham wanted to offer free transfers to save commuters money, and he hoped to rebuild the tracks on Main Street in Bangor.

And finally—what everybody wanted to know—he planned to repaint all the buildings, build some new ones and expand the playground at Riverside Park, the summer amusement complex the company owned on its trolley line in Hampden. It was a surefire way to get people to ride the trolley in warm weather.

On April 24, Graham appeared before the Bangor Board of Trade to give a speech on the new operation and his accomplishments during the past three years:

The Bangor Railway & Electric Co. is a consolidation of seven or eight different companies—companies which could give no service whatsoever if operated alone, but which with their resources gathered into a common fund and with the economy which comes from all consolidation are enabled to give service unexcelled in any city of Bangor's size in the world.

He used the little trolley system across the Penobscot River in Brewer as an example.

When I first came to Bangor there were two cars over there, each run at an approximate loss of $4 a day. I removed one of the cars, established an exact 15-minute schedule, put up some white poles to facilitate the working of this schedule—and what has been the result? Instead of two cars each losing $4 a day, we have one car which makes from $8 to $12—and the people are better satisfied.

Making the trains run on time was a major goal, he explained.

It was essential, I soon discovered, that the cars of Bangor run on exact time—a thing they had never done. I started in to make some changes, and now, our time is as nearly perfect as patience and skill can make it.

Horsepower had also been boosted to make the cars run more smoothly and efficiently. The bottom line, he said, was that more people were riding the cars and profits were increasing.

Graham understood that his company's success as the years passed would depend more on revenue from commercial power and light and less on street railways. He pondered how to make the transition.

"Always the pattern was the same. First came railway service, both freight and passenger, quickly followed by distribution lines of power and light," said his son Edward, who wrote an account of his father's life.

The pattern proved true. The Bangor Railway & Electric Company became Bangor Hydro-Electric Company in 1925 using the framework Graham had established. The last trolley ran in 1945, a victim of the automobile and the bus. Most people had electric lights and appliances by then.

WHEN BOSTON BOATS COLLIDED

June 12, 2006

Bangor residents were proud of their steamboats a century ago. The biggest, called "Boston boats" because of the route they took, were mighty symbols of the age of industrial progress. Those "great white flyers" of the Eastern Steamship Company, with their powerful engines and luxurious accommodations, provided evidence to the people of the Queen City that their connection to the outer world was secure. So when the two most glamorous Boston boats, the *City of Bangor* and the *City of Rockland*, collided on June 7, 1906, it was disturbing news, spread across the tops of the front pages of the city's two daily papers.

Even a minor collision like this one was reason for the most confident soul to pause and contemplate the hairline cracks in the veneer of his gilded world. Nobody had died. Nobody had been seriously injured. But there were so many ifs. What if the crash had happened two seconds earlier or if the seas had been a little rougher? What if First Officer Thomas Birmingham of Bangor had not saved the day?

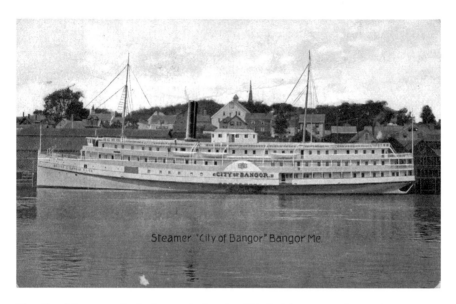

Steamer "City of Bangor" Bangor Me.

The *City of Bangor* was badly damaged when it collided with another "Boston boat," the *City of Rockland*. *Courtesy of Richard R. Shaw.*

The *City of Bangor*, on its way to Boston, and the *City of Rockland*, headed for Bangor, collided at two minutes after midnight on June 7 in "thick and nasty" fog twenty miles east of Portland. Captain William A. Roix, who was at the wheel of the *Rockland*, said he heard the *Bangor*'s whistle about three-quarters of a mile away. Then, with the help of the full moon, which periodically broke through the mist, he saw the bigger vessel about a half mile away.

Despite the avoidance maneuvers undertaken by both vessels, the *City of Bangor* struck the *City of Rockland* a glancing blow about 10 feet forward of its stern. If the *Rockland* had not been going at full speed, the *Bangor* would have struck it squarely amidships and sunk it, said Captain Roix. A second account by an unnamed officer from the 274-foot *Rockland* predicted that both ships would have sunk had the *Bangor* struck the *Rockland* two seconds sooner.

Captain Ezra W. Curtis of the 277-foot *City of Bangor* refused comment to the press. But a University of Maine student, J.H. Mason of Beverly, Massachusetts, who happened to be sitting on the hurricane deck of the *Bangor*, said the *Rockland* cut across the *Bangor*'s bow in what appeared to be "a confusion of signals." Others complained that the *Bangor*'s whistle was too weak to be heard. And so the accounts of what happened multiplied.

There were two hundred passengers aboard the *Rockland* and fifty aboard the *Bangor*. Three staterooms were crushed on the former vessel, and Mrs.

Elmer Crowell of Woonsocket, Rhode Island, was thrown from her berth, stunned and bruised, the only casualty. In another stateroom, two girls from Aroostook County on a high school trip had to be removed through a window when their door jammed. As for the *City of Bangor*, its prow was badly smashed and its stem twisted.

The *Rockland* continued on its way after staying with the *Bangor* until its cargo had been transferred to another vessel and it was safely headed into Portland Harbor. "If the weather had been rough it is believed she would have sunk within an hour," reported the *Bangor Daily Commercial* that afternoon.

By the next day, a hero had emerged in the newspaper stories—a Queen City resident played a key role, at the risk of his own life, in keeping the *Bangor* afloat. On June 9, the *Bangor Daily News* reported:

> *Everybody is uniting in praising the bravery of First Officer Thomas Birmingham of the* City of Bangor, *who lives in this city, who stood alone, waist deep in water, plugging mattresses in the jagged bow of the steamer, for half an hour stopping the inrush of water. He was working in the dark, not knowing whether the boat would go down under him or not any minute.*

A Portland paper added:

> *Thomas Birmingham, the mate of the* Bangor, *distinguished himself after the accident by crawling down the stem of the steamer to her water line and stopping whatever leaks there were or were likely to develop, with mattresses, canvas. etc. This was done with the steamer pitching considerably. For while it was very calm, so far as wind was concerned, there was considerable of a sea on and the deed was one which required considerable nerve and skill.*

The *City of Rockland* was getting a reputation for bad luck. Doubtlessly, many reading the press accounts recalled the wreck of the vessel two summers before on a ledge off Owls Head, with four hundred passengers aboard. It was another close call. Not even the most prescient readers, however, could have foreseen the other accidents that lay ahead for the *City of Rockland*, culminating in a wreck in 1923 at the mouth of the Kennebec River that would end the vessel's career.

The story about the accident on June 7, 1906, on the front page of the *Bangor Daily Commercial* overshadowed a much shorter piece farther down on page one about the launching of the world's largest ocean liner—the steamer

Lusitania—in Glasgow, Scotland. That must have seemed like such a trivial bit of news next to the collision of two mighty Boston boats. Only hindsight allows us to judge the relative significance of these two stories today. Readers probably would not remember that on this day, as they were worrying about their next steamer trip to Boston, they had also read about the ship that, nine years later, would sink off the coast of Ireland, the victim of a German torpedo. The 1,198 dead included 128 Americans, which helped ensure the United States' entry into World War I.

THE B&A's PUSH TO THE SEA

November 28, 2005

Railroads were once the backbone of progress. If your town got a new railroad line, it was time to celebrate. So when the new Northern Maine Seaport Railroad began its first passenger run at 5:50 a.m. on November 27, 1905, from Searsport to LaGrange by way of the outskirts of Bangor, newspaper reporters were there to record the event. Hardly anybody else was on board at that early hour, however, except the crew and a few "deadheads," the term for railroad employees and others who rode on free passes.

Franklin W. Cram. *Courtesy of Richard R. Shaw.*

A groggy reporter from the *Bangor Daily News* wrote:

> *There was no imposing ceremony, no firing of cannon or waving flags.*
> *Conductor L.R. Norwood just told Si Messer to let 'er go. Si yanked the*
> *throttle on old No. 14 while Jack Wallace shook up the fire a little and*
> *train No. 101 went rolling down through the cut and skirted the harbor*
> *shore bound northward.*

The train passed over fifteen new steel bridges and by sixteen new stations, including the one in North Bangor near Six Mile Falls, where Bangoreans could make the connection by riding the electric trolley from downtown. There was already talk that Bangor businessmen would be able to hop aboard the train after work to visit their families at summer vacation destinations on the coast and return the next morning in time to be at their desks.

Just 29 passengers had boarded by arrival at LaGrange two hours later. On the way back, whole delegations boarded from some little towns. At Searsport, hordes of "young lady snap-shotters" were on hand. The total that day was a modest 144 paying passengers on this new branch of the Bangor & Aroostook Railroad.

Before it built the Northern Maine Seaport Railroad, the B&A's southernmost terminal was at Old Town, where it connected with tracks to Bangor owned by Maine Central Railroad. Getting lumber, potatoes, paper and other products to a port such as Bangor's was becoming more expensive and inconvenient. The cost of the coal it loaded from ships was seriously inflated by the situation. The fact that Bangor was iced in three or four months of the year added to the problem.

The new railway and the creation of coal, freight and passenger terminals at Stockton Springs and Searsport would give the B&A the kind of independence it needed to stimulate the economy of Northern Maine, said Franklin W. Cram, the railroad's president.

People in the little towns along the new road were excited about the economic boost they thought was coming to their towns. Stockton Springs, for example, had already enjoyed a land boom when the railroad bought up much of the harbor front property. "Resurrection of Stockton Springs," declared a large headline over a lengthy story in the *Bangor Daily Commercial*. Businesses were expanding, and the population was on the rise after years of decline.

People in the Queen City, however, had mixed feelings. They hoped the new line would lower freight and passenger rates by giving the Maine Central some competition. But some feared that the new tracks to the sea would

deal a crippling economic blow to the port at Bangor, diverting lumber and potatoes to the coast.

A description of the construction in the December issue of the *Industrial Journal*, a Bangor business paper, shows that they had good reason for concern. At Mack Point, not far beyond the Searsport station, a huge dock, about 500 feet long and 40 feet wide, for discharging coal and an immense coal handling plant were under construction. At Kidder Point, between the Searsport and the Stockton stations, there was a steamship landing with a wharf, 800 feet long and 150 feet wide, and buildings for freight and passengers under construction.

At Cape Jellison in Stockton Springs, construction of "mammoth terminals" for cargo was underway. "An idea of the stupendous magnitude of these terminals…can be gleaned when it is stated that the main wharf is 1,600 feet long, 600 feet of this being 80 feet wide and 1,000 feet of a width of 200 feet," reported the *Industrial Journal*. Steamships were lining up for business. The steamer *Foxhall* had already left Stockton Harbor with a load of potatoes bound for Texas.

Nevertheless, the *Bangor Daily News* took a boldly optimistic position. In an editorial entitled "Bangor's Emancipation," the newspaper said:

> *The tidings of great joy for Bangor are in the air. After being tied up to the ringbolt of one railroad during all of its active existence, this city is soon to have a second outlet by land to the markets of the world…Whatever rates that may be arranged from now on can no longer be decided by the fiat of any power from which there is no appeal.*

But just to be on the safe side, a group of Bangor businessmen applied for a charter to start their own connector line from downtown to Northern Maine Junction in nearby Hermon, where the new train would have an interchange with the MCRR.

Would Bangor benefit from railroad competition or lose a seaport? When asked about this dilemma, President Cram was hardly reassuring. He told a *Bangor Daily News* reporter:

> *What was good for the big and growing country north of Bangor was good for Bangor; that business must follow natural channels—the most economical ways, and that, if in the resultant development of the north, Bangor failed to get a rich share, then it would be because Bangor merchants and others lacked in enterprise and ability to grasp opportunities.*

At the end of his story, the reporter informed his readers, with newsman's license, of just what they wanted to hear:

> *Bangor will always be a great seaport, and in the natural course of events, she must become an important commercial city, and in the great country to the north are money-making opportunities for legions of workers, and as storekeeper for these money makers she stands beyond competition.*

New Train Station Meant Bangor Had Arrived

July 23, 2007

A special train consisting of private cars 444 of the Boston & Maine Railroad and 666 of the Maine Central pulled up to Bangor's brand-new Union Station at 7:00 p.m. on July 23, 1907. Among the dignitaries aboard was Lucius Tuttle, president of both railroads.

A large crowd had gathered to see Tuttle and other dignitaries, but the important men sat in their luxury cars waiting to be escorted into the station. "All the satisfaction [the crowd] could get was in watching the colored porters cleaning up and sweeping out," remarked a reporter for the *Bangor Daily News*.

After two years of planning and construction, and after $500,000 in spending, the new train station, which more than any other building would assume an iconic presence in the city's history, was about to be dedicated. The Queen City had finally arrived, after years of frustration in dealing with the railroads. It was a symbol of Bangor's wealth and prestige. Tonight, "big guns in the railroad world" would be booming a salute to Bangor, wrote the reporter.

The banquet room, the station's future restaurant, was festooned with two hundred silk flags from countries around the world. Potted palms and other plants were tastefully arranged. A ten-piece orchestra played. Everyone who was anyone was there, from Mayor John Woodman to Isaiah Stetson, president of the Bangor Board of Trade. Among the many features on the menu was boiled Penobscot River salmon with hollandaise sauce, a reminder of the Queen City's productivity and self-reliance.

The multitude of distinguished speakers that evening made their points succinctly beginning at 11:00 p.m. through a haze of after-dinner cigar smoke. "There is nothing more untrue than the report…that the great transportation managers sit aloft from their fellows—entirely regardless of the public—that

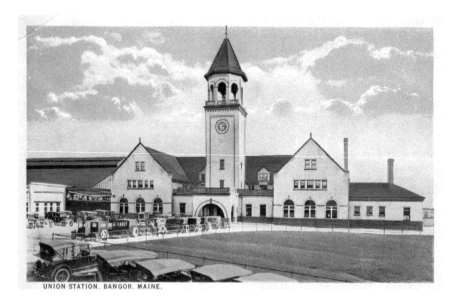

UNION STATION, BANGOR, MAINE.

Union Station. *Courtesy of Richard R. Shaw.*

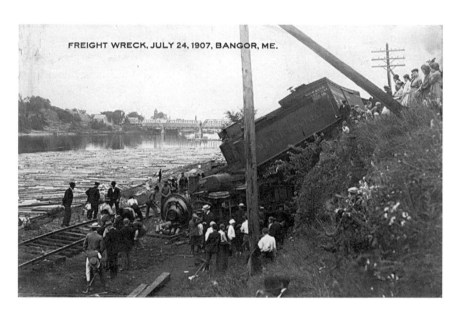

FREIGHT WRECK, JULY 24, 1907, BANGOR, ME.

This fatal train wreck occurred in Bangor a few hours after the dedication of Union Station. *Courtesy of Richard R. Shaw.*

they respect nobody's rights and care only for big receipts," asserted President Tuttle. "Why the erection of this beautiful station is an illustration that the Maine Central, for instance, is trying to do the best it can by Bangor."

In response, William T. Haines, a Republican gubernatorial candidate from Waterville, said that the public appreciated all that had been done, but it wanted more—more tracks, more safety measures, more cars, lower freight rates. His comments were vigorously applauded, commented the *Bangor Daily News* reporter in his account on July 24.

Coincidentally, in an event that had little to do with the new train station, but a lot to do with safety, Engineer Adam Markley was killed a few hours after the conclusion of the dedication when the air brakes failed on his locomotive and it plunged fifteen feet over an embankment at the Eastern Yard, opposite Newbury Street.

The building of Union Station was the climax of the city's long and impressive railroad history. The Bangor & Piscataquis Canal & Railroad Company ran the first steam railroad in Maine from Bangor to Stillwater in 1836. In the years ahead, different companies stretched the tracks all the way to St. John, New Brunswick, according to a piece on Bangor railroad history in the *Bangor Daily News* on July 29 (the issue was incorrectly dated July 28). The first train to run west from the city was operated by the Penobscot and Kennebec Railroad in 1855. Eventually, the Maine Central acquired the rights to these lines. A new railroad, the Bangor & Aroostook, had begun serving Central and Northern Maine only a few years ago, a testimony to the area's great economic growth.

Stations handling passengers and freight had grown up on both sides of the Kenduskeag Stream. The new Union Station was built on the east side at the foot of Exchange Street after the old railroad building there was torn down. Now it was time to tear down the decrepit station on the west side of the stream at the foot of Railway Street. Not only had this station seen the first train go west from Bangor, but it had also witnessed the departure of troops in 1861 and 1898. Four presidents had passed under its roof: Grant and Roosevelt had visited Bangor, while Harrison and Cleveland had been on their way to Bar Harbor, said the newspaper.

The opening of Union Station resulted in some predictable controversies in the first few weeks. Hack drivers and public carriage drivers clashed over who would get to park nearest the new station. And because gates, fences, paving and other safety measures hadn't been completed, several people were killed or injured at the train yard and various other points, such as at the new railroad bridge over the Kenduskeag and near the ferry landing.

Exchange Street had been transformed. "Formerly it was a staid old street and about all one heard…was shipping and lumber talk, but now…hacks hurry up and down the street in a steady stream and crowds come and go along the sidewalks," remarked the *Bangor Daily Commercial* on July 30. The *Bangor Daily News* noted on August 7 that the foot of Exchange Street was no longer "a haven for loafers, dreaded at night." No one mentioned all the illegal saloons.

How long would this new train station last? There was "the possibility that in another half century this station, as the old, will be outgrown and antiquated and unfit for the tremendous run of traffic," speculated a *Bangor Daily News* reporter. He was only off by a few years. Union Station was torn down in 1961, an event still mourned by many Bangoreans. What the reporter did not foresee, and probably never could have imagined, was the demise of train passenger service as well.

BANGOR'S FIRST SPEEDING TICKET

May 21, 2007

A century ago, "the auto craze" swept through Maine. One did not need to be a prophet to see that the number of automobiles in Bangor would soon double, making them "as plentiful as grasshoppers in an August stubble," rhapsodized a *Bangor Daily News* editorial on May 14, 1907.

All told, Maine had registered more than eighteen hundred autos as of June 18, said the newspaper. The next day, the *Bangor Daily Commercial* estimated that there were more than one hundred autos owned in Bangor. Of course, dozens more appeared in the Queen City, driven by tourists.

All these new motor machines were causing an uproar. "During the past few days there have been numerous narrow escapes of persons being run down by automobilists," reported the *Commercial* on May 21 in its new column called "Automobilia." "It is said that some of the autoists are disposed to exceed the speed limit in some sections of the city."

The police decided it was time to get tough. A speed limit of eight miles per hour within one mile of the city's post office (and fifteen miles per hour in the rest of the city) had been established the year before, but no one had ever been prosecuted. Considering that the police had no automobiles or radar guns, it is instructive to learn how the Queen City issued its first speeding ticket.

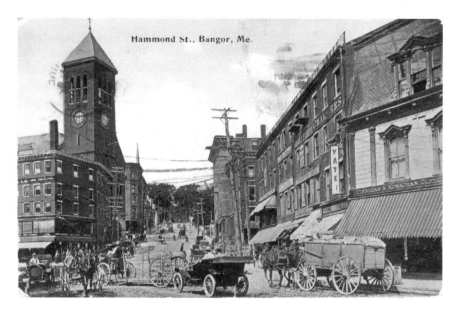

Hammond St., Bangor, Me.

Horses and automobiles were just beginning to compete for space in downtown Bangor during the first decade of the twentieth century.

Joseph Foster, a chauffeur for lumber dealer Waldo P. Lowell, was the recipient on Friday, May 24, 1907. Foster's violation had actually occurred the day before, but Patrolman Simon O'Leary, who had been watching the chauffeur's antics for some time, needed to organize this momentous case. The wheels of justice turned quickly, however. By Saturday morning, Foster was on trial in Bangor Municipal Court.

Patrolman O'Leary testified that Foster was speeding up Exchange Street, where his employer's office was located, at 2:30 p.m. when he almost hit a man and a woman crossing at the corner of State and Exchange Streets. Foster turned the corner to go up State Street Hill, and the machine "slewed" (think mud or loose gravel) and nearly tipped over. O'Leary said that, in his judgment, Foster was going more than eight miles per hour. He had witnesses to back him up.

Freeland Jones, a lawyer, had been sitting in his office in the Granite Block when he saw Foster's car skid and then "wobble" as it turned the corner. Jones couldn't judge the speed, but John M. Lynch testified that Foster was "going like a streak." Both he and witness H.A. Jefferds agreed with O'Leary that the speed was well over eight miles per hour. Then Police Chief John C. Bowen sewed up the case, testifying that Foster had been warned several times, but had merely laughed and "defied arrest."

Foster was fined the limit of $20.00 plus costs of $8.93. We have no account of his comments or those of his employer. But the newspaper writers were content. "Bangor is getting more metropolitan everyday," declared the *Bangor Daily News* proudly, while the *Commercial* noted, "At last, Bangor is getting up with the procession."

Exchange and Main Streets were thoroughfares of special concern to the authorities. Another sore spot was the Bangor–Brewer bridge. It had been a covered bridge until 1902, when a flood knocked out its center. The repairs resulted in a jury-rigged affair—an uncovered steel span in the center with the older wooden covered portions remaining at either end. The covered wooden roadway was divided down the middle at each end, but the steel portion had no divider.

Reckless automobilists, seeing a line of slow horse-drawn wagons in front of them at either end of the bridge, would take off down the wrong side of the divided roadway, moving back into their lane on the undivided steel span. Sometimes they would make this dangerous maneuver while on the steel portion to get more quickly to the end, according to the *Bangor Daily Commercial* in its "Automobilia" column on May 21 and in a story on May 30. One autoist had already injured a horse in this manner.

These issues were only the beginning of a century of growing concern about the impact of the automobile on society. In 1907, people knew that the automobile would cause problems even if they were not always correct about what those problems would be. Some people called them "devil carts." Farmers viewed them as a threat to agriculture, scaring their horses and other livestock and interrupting their work on narrow country roads. Numerous accidents involving runaway horses, sometimes fatal, were recorded in the newspapers, affecting everyone who depended on horses to pull their wagons and carriages.

The arrest and conviction of Joseph Foster, chauffeur, was a major event in the effort to keep roads safe. But there were many other issues, as well. Autoists were already draining customers away from state-supported electric trolleys and steam railroads, as well as causing wear and tear to public roads, the *Bangor Daily News* noted in editorials on May 14 and June 14. Higher taxes were one solution, said the Honorable Fred Atwood, a former state senator from Winterport. "Tax the Devil Carts," the newspaper echoed in an editorial headline. The century ahead would witness the creation of plenty of taxes on autos, highways and fuel, although the problems, now including highway gridlock and global warming, seem boundless.

BANGOREANS LOVED
A HOLIDAY

MAYHEM RULED ON THE FOURTH

July 4, 2005

The Fourth of July got off to an early start in Bangor a century ago with a fire in Estabrooke's cigar store in the Old Jones Block on Hammond Street. It spread into the basement, which was bulging with rockets, roman candles, firecrackers, pinwheels "and every other device that has been invented to help the youth of the country remember their heritage," reported the *Bangor Daily News* on June 30, 1905.

Within ten minutes of the alarm being pulled, the celebration began. "Rockets roared and swished and thrashed in the narrow confines of the basement," wrote the reporter, who had most likely run up to the scene from his nearby office on Exchange Street. "Fire crackers sputtered and Roman candles went off in spasmodic puffs. The firemen beat a hasty retreat until the observance should have been completed."

That was just the beginning of what we call euphemistically "an old-fashioned Fourth," back when small bombs and other celebratory weapons were still legal. Miraculously, nobody was killed or dismembered that year, at least in Bangor.

Officialdom did what it could to channel the annual hooliganism into something constructive. There were plenty of public events to attend—a lot more than there are today in this era of the automobile, television and the backyard barbecue.

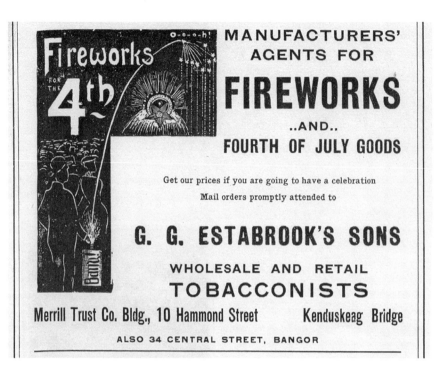

MANUFACTURERS'
AGENTS FOR

FIREWORKS

..AND..

FOURTH OF JULY GOODS

Get our prices if you are going to have a celebration

Mail orders promptly attended to

G. G. ESTABROOK'S SONS

WHOLESALE AND RETAIL

TOBACCONISTS

Merrill Trust Co. Bldg., 10 Hammond Street Kenduskeag Bridge

ALSO 34 CENTRAL STREET, BANGOR

Fireworks were readily available a century ago.

You could go to the circus in Calais or board the double-turreted monitor USS *Puritan*, anchored off Eastport.

You could hear the Declaration of Independence read at the Waterville fairgrounds or watch the naphtha boat race on Sebasticook Lake, the winner powered by a four-horsepower engine.

You could watch Joseph LaRoux, the famous aeronaut, parachute to earth after being shot out of a cannon suspended from a balloon at the "$2,000 celebration" in Bar Harbor. You could run in "the fat men's race" at Utopia Park in Warren.

Or you could attend Culbert's Wild West sham battle featuring the Hamlin Rifles as the Indians and the high school cadets as the U.S. Army at Maplewood Park (now Bass Park) in Bangor.

You could attend baseball games, run three-legged races and hear band concerts just about anywhere. Thousands of people attended these events.

But to see the real Fourth, the one performed by the street urchins of Bangor, you had to go downtown, where it sounded like a reenactment of

the Battle of Port Arthur, as those people who had been following the Russo-Japanese War in the newspapers liked to say.

Those residents with the wherewithal fled to their camps on Hermon Pond, Greene Lake and a host of similar places, or they took the B&A excursion train to Moosehead Lake or the excursion steamer *Verona* to Rockland, where a squadron of warships was in the harbor. Or they took the trolley to Riverside Park in Hampden, where the entertainment lasted long after dark.

The celebration began in Bangor about 6:00 p.m. on the night before the Fourth on Main and Exchange Streets and especially in West Market Square. "Pandemonium was let loose in a blaze of red fire and patriotic joy," wrote the *BDN* reporter. "The police did not interfere, although according to law no firearms could be properly discharged till midnight—it would have taken the entire force anyhow to cope with the spirit of frenzied enthusiasm which animated younger Bangor."

With dynamite caps blasting, blank cartridge revolvers firing and cannon crackers exploding, things started to heat up as the night went on. "By ten o'clock save for the street car lines all ordinary traffic was suspended and the entire business section of the city was given over to deliriously excited boys."

Two days later, the newspaper assured its readers that there had not been a single serious accident. But people had a high tolerance for violent injuries back then. In fact, former state representative Frank Tupper had received serious powder burns when a firecracker blew up near his face, and newspaper carrier Jerry Sprague was hurt when he fired a blank pistol into his face. "He will be disfigured, but the wound is not dangerous," the newspaper reassured readers.

Then there was the unidentified Bangor woman who fired a blank pistol at her husband on the morning of the Fourth to wake him up. "The doctor stated it would take an hour a day for a week to pick the powder grains out," the paper recorded.

Nineteen men were locked up for drunkenness at the Bangor Police Station.

At a large event in Newport sponsored by the fire department, eighteen firemen were deputized after a rumor spread that "evil-minded men of Bangor" were coming with bags stuffed with liquor bottles "to corrupt the morals and inflame the brains of our sober country youth." These mysterious men thought better of their plot and no one was arrested.

But things did get out of hand in Aroostook County. In Houlton, rioting men broke a plate-glass store window, tore down signs and tried to set a fire

in Market Square. "I have lived in this town all my life. I have been on the police force a number of years but the crowd about the streets last night was the toughest and the hardest to control that I have ever seen," moaned Officer Monson.

And blood flowed freely on a B&A train on July 5, when a group of a dozen Millinocket men returning from a celebration in Fort Fairfield discovered that their round-trip tickets had run out the day before. The dispute was quelled in Bridgewater, where one of the men was arrested and the others jumped out of the train windows and fled.

At the station in Bangor, the blood on Conductor Gillin's normally immaculate uniform was evident, and more was seen on the floor of a car where windows had been broken.

"Smash-up?" asked a station lounger.

"'Nother Aroostook War?" suggested a second loafer.

"Neither," replied Mr. Gillin decisively. "It was a scrap."

Thus ended another old-fashioned Fourth.

THANKSGIVING OFFERED PLENTY OF ENTERTAINMENT BESIDES EATING

November 19, 2007

Thanksgiving featured a lot more than turkey and stuffing a century ago. Dances, boxing matches, hypnotism shows and moving pictures were among the entertainments that got people out of their houses for much of the day in Bangor.

But first, a few words about turkeys. If you were looking for a good one, best not go to the Pickering Square farmers' market.

This had not been a good turkey year for local farmers, who mainly had chicken and "fowl"—probably geese and ducks—to offer. Most "native turkeys" actually hearkened from Vermont or New Brunswick, the *Bangor Daily Commercial* confided to its readers. Most Maine turkeys came from Aroostook County, where the royal bird was taking a backseat to potatoes these days.

Perhaps it was best to buy at a store. Lynch's Market on Park Street in East Market Square promised "no embalmed turkeys"—only the genuine native kind, which newspaper readers had already learned probably came from Vermont or New Brunswick. Then, one could pick up a genuine plum

A century ago, many Bangoreans bought the fixings for their Thanksgiving dinners at the city's outdoor market in Pickering Square.

pudding at the New York Cooking School at 146 Main Street, along with a few other fixings, and have a meal fit for one of Bangor's fancy hotels.

But why not just go out to dinner at one of those hotels? The Windsor was serving roast stuffed Vermont turkey and more than a dozen other items, including green turtle soup, roast green goose and green apple pie. The Bangor House's offerings included potatoes à la Nontais (doubtlessly from Aroostook County), lobster patties and a saddle of venison. Diners at the Penobscot Exchange feasted on blue points on the half shell, Minniehaha cake and much more.

Of course, there were many poor people who needed help, and Bangor gave generously, said the *Commercial* on November 29, listing donated items for the Bangor Children's Home, the King's Daughter's Home, the Home for Aged Women and the Good Samaritan Home. Meanwhile, a large number of homeless people, known as "shelters," were taken in at the city jail. The police reporter did not describe their meal, only that they "thought themselves lucky even to have a bed on Thanksgiving."

After dinner, opportunities for entertainment were legion. Three dances were scheduled—two dance matinees at Bangor and Brewer City Halls and an evening affair at Society Hall featuring Pullen's Orchestra. The city's dance scene had opened earlier in the month with the first major dance, the

Letter Carriers' Concert and Ball, followed by the concert and ball given by the Firemen's Relief Association on Thanksgiving Eve. The latest dance craze—the bucking heifer or barn dance as it was also called—had already ignited a debate in the newspapers. Was it new or a revival of "the old Military scottische" from twenty years ago?

The curmudgeon sent to review the Letter Carriers' Ball for the *Commercial* reported back on November 19 that the women were wearing "the most peculiar headgear...Many of them looked like inverted half-pint dippers with feathers for handles." The young men, meanwhile, were engaged in an "absolutely idiotic fad," causing them to "run around with their trousers rolled half way between their ankles and their knees." Doubtlessly, these fashions lasted at least until Christmas.

Sports fans had a choice between football and boxing. The Shamrocks defeated the Emeralds at Maplewood Park. Not surprisingly, most of the players on these local teams had Irish surnames. The game was played in a sea of mud. Nevertheless, onlookers crowded onto the field to get a closer look until Inspector Calvin Knaide arrived. "He kept the field clear and if anyone ventured into forbidden territory he got his," commented the *Bangor Daily News*. "If Cal's orders weren't instantly obeyed, it was because the trespasser was stuck in the mud."

That evening, Belfield Walcott, "the sturdy colored boxer," and Kid Egan, "formerly champion of the American Navy," slugged it out at the arena, the Queen City's new boxing spot on Franklin Street. It was the best bout seen in Bangor in a long time, even though Egan was "inclined to loaf at times."

The crowd was small, many Bangoreans preferring something a little lighter on top of their heavy dinners. For them, Prescelle, the hypnotist, and his assistant, Edna May Magoon, drew a large crowd at the opera house, as did the three films showing at Bangor's new movie house on Central Street, the Nickel. They were *The Wonderful Lantern*, *A Gold Brick* and *Ice Industry in Sweden*.

Bangoreans had time for intellectual pastimes as well on Thanksgiving. Dr. Wilbur F. Crafts, superintendent of the International Reform Bureau, spoke in the evening at the Universalist church on "Our Boys and Girls." He had just returned from a fourteen-month tour of four continents, where he had been "conducting a crusade against rum and opium as the supreme curses of the colored races," said the *Commercial* the day before Thanksgiving.

In the same issue of the newspaper was an advertisement for mail-order liquor, three dollars for four quarts of Parkwood Club unmixed whiskey, plus a free bottle of wine from R.A. Splaine & Company of Haverhill,

Massachusetts. It was all perfectly legal to get liquor through the mail, despite Maine's much maligned prohibition law.

The day after Thanksgiving, the *Commercial*'s police reporter commented that only two cases of intoxication came before Bangor Municipal Court, an unusually low number "after the great Yankee holiday." Bangor arrested more people for drunkenness than all other crimes combined. The city set a record the year before. Whether Dr. Crafts mentioned any of this in his talk is unknown.

The Mysterious Christmas Baby

December 19, 2005

The annual Christmas whirl was underway and Bangoreans were properly dizzy. "Christmas Will Be Gay This Year: Great Confusion of Dances and Dinners and 'Parties' For Next Two Weeks," said a headline in the *Bangor Daily News* on December 19, 1905.

The agenda included the annual visit by the Tufts College Glee Club and a YMCA sale. Two Bangor High School organizations, Alpha Phi Fraternity and the Yaker Club, were putting on dances and a sleigh ride. A subscription

Businesses often issued Christmas advertising cards. *Courtesy of Richard R. Shaw.*

dance was scheduled at city hall and private dances at Society Hall and Memorial Parlors. A half dozen house parties at nearby lakes, a long string of dinners and card parties and informal house dances rounded out the schedule. Much of the festivity was fueled by the arrival of dozens of college students from Harvard, Vassar and a host of other exclusive schools where Bangor's wealthy sent their children in the era before financial aid.

Then there was the matter of buying presents. It could drive one insane, as a newspaper reporter tried to show:

> *Tuesday morning the police received a call from the shopping district to arrest a crazy man. They proceeded with great haste to a retail store and found a poor unfortunate wanderer crazed with the desire to buy gifts and lamenting his lack of money.*

After the paperwork was filled out by a physician, the man was taken to Eastern Maine Insane Hospital in the patrol pung, singing all the way, the reader was informed.

The newspaper added its own incentive for holiday stress. An editorial writer told readers that the only way to celebrate Christmas properly was to spend until you were broke: "That is what Christmas is for, to cause us to give until we are poor...It is then and not until then that we receive the true Christmas spirit."

If the newspaper's advertisements were an indicator, there was no shortage of things to buy. Durgin's Bangor Bazaar on Main Street had "dolls by the thousands," while the Chas. E. Black Shoe Company on Hammond Street was offering leggings of fine quality jersey cloth for women and overgaiters for either sex. Whiton's Carriage Repository on Harlow Street tried to interest shoppers in sleighs, pungs and fur carriage robes. J. Waterman Company on Exchange Street was selling Turkish bathrobes, holiday suspenders and Alaska seal caps for men. Rice & Miller, a hardware store on Broad Street, advertised carriage and sleigh heaters and toy ice cream freezers. S.L. Crosby Company on Exchange had lots of Edison phonographs and records, as well as "skees" for "skeeing."

The day before Christmas, the annual Christmas party at city hall was held for five hundred "worthy poor children." It was organized by the city missionary, Mrs. H.A. Wentworth. Her husband played Santa Claus. His novel entry to the festivities in 1905 caused not a few satirical observations in the paper, even though he was almost killed.

Tired of coming into the auditorium each Christmas through the door, Wentworth decided to descend from the attic opening high above

the city hall auditorium on the end of a rope held by two burly Irish cops, Inspector Knaide and Captain O'Halloran. Grabbing the wrong end of the rope, however, Wentworth shot through the opening headfirst, terminating his rapid journey hanging by his ankle with his head a few inches from the floor.

"The children, who failed to appreciate the gravity of the situation, were tickled about half to death," a *Bangor Daily News* reporter commented drily.

Doubtlessly, some of these same poor children were out on Christmas morning on Cedar Street participating in the spontaneous "coasting" party that lasted all day and into the night. According to the *BDN*:

> *The hill with its long slide from Fifth Street down into the hollow—and it is a ripping good bob—up over the bunch to Second Street has for generations been a favorite coast. Noisy gamins in moccasins...had no end of fun with home-made bobs, which frequently broke down or fearfully ticklish contraptions made of barrel staves which jumped and gyrated...The skee-ing fever has hit the town hard, and skees, from the fancy "boughten" patterns to "some father made" vied with the sleds, bobs and toboggans.*

Some old-timers remembered when the hill was a glare of ice and there were no electrics trolleys on Main Street. Back then,

> *some of the famous old flying bobs have started at Fifth Street, shot down Cedar Street with speed enough to take the rise from Sanford to Second, then another long swoop down across Main, around into Summer Street, finally ending a wild ride of nearly a mile in South Street—and that was going some.*

But perhaps the most talked about Christmas gift that year was the one presented to Mr. and Mrs. Henry P. Gerrity of King's Court across the river in South Brewer. On Christmas Eve, a baby girl wrapped up in woolen blankets and lying in a basket appeared on their doorstep. The Gerritys, who were described as respectable—he having a good-paying job with the Eastern Manufacturing Company—had no children of their own after sixteen years of marriage, according to the *Bangor Daily Commercial*.

As Mrs. Gerrity looked out the door that night after discovering the child, she noticed at the foot of the hill a closed carriage being rapidly driven away into the darkness. There was no way to tell who was in it or which way it went, she said. A few days later, no clue had been offered as to the baby's

identity, and Mrs. Gerrity hoped that the speculation would stop, as she wanted to keep the foundling. And that is where this column will end until more can be revealed about the Christmas baby of 1905.

"MEET ME AT FREESE'S"

May 28, 2007

Department stores were magical places a century ago. Bangoreans, like other Americans, admired the big plate-glass windows, the electric lights and the elevators, if available, as well as the well-starched clerks, the ready-to-wear clothes and the other modern amenities.

Several of these palaces of mass consumption were located in the Queen City. J. Waterman Company, J.C. White & Company and Benson & Miller were among them. Chain stores had arrived as well, including Besse-Fox Company and C.S. Woolworth & Company. But it took one man named A. Langdon Freese to show Eastern Maine how big and important a department store could be.

In 1892, at age twenty-three, Freese opened a little store in rented quarters at what became 80 Main Street, "about where the ladies hosiery counter of Freese's Inc. now stands," said his obituary sixty years later. It occupied the

Freese's Department Store was already rapidly expanding at the time of this early photo, taken at the beginning of the twentieth century. *Courtesy of Richard R. Shaw.*

space of "half a store," about twenty by sixty feet, with only one window. Within a year he had doubled the size, and that was just the beginning.

By 1906, Freese was considered "a rising young merchant, the proprietor of one of the most prosperous and popular dry goods houses in the state," declared the *Bangor Daily Commercial* on July 3 after the young entrepreneur bought property next door for a major expansion of his business. "Freese's is a household word over a large part of Eastern Maine and the store is one of the best known in the city."

His department store had become so busy that Freese had recently purchased the remaining half of the block of stores at 74–78 Main Street. Freese had bought the first half on March 1, said the newspaper. Renovations would begin, including the removal of partitions, the addition of a fourth story on part of the store and an extended back, installation of an electric elevator, steel ceilings, modern lighting and other amenities that would attract even more shoppers.

The grand opening of the expanded store was on May 18, 1907. Freese's now stretched from 74 to 86 Main Street, where the Maine Discovery Museum is today. The street floor encompassed what had formerly been five different stores.

"We keep almost everything," Freese promised in a newspaper advertisement announcing the gala event. The store featured a grand variety of "the newest styles in millinery, flowers, waists, etc." It stocked ready-to-wear clothes for those with some extra money, as well as material for families that made their own. (In 1907, there were also about forty-five dressmakers and a dozen tailors operating in Bangor, according to the city directory.)

The grand opening was a high-class affair. Hall's Orchestra played band music. A Sousa march, a waltz by Victor Herbert and other popular tunes entertained the admiring crowds. "It's certainly the golden age for Freese's," declared the *Bangor Daily News*.

A larger advertisement two days later waxed poetic: "The lightest, brightest cheeriest salesrooms in Maine. A flood of light. A garden of white. An inspiring sight. Looks like a beautiful scene when you first get a glimpse of it."

All sorts of exotic products were available, including new china silk waists, black taffeta jumpers, white dotted Swiss muslin, Marseilles white soap, dimity and batiste, Japanese crepe kimonos and "the greatest ribbon bargain you ever had in Bangor." Imagine the reactions of the wives of farmers and mechanics, and the clerks and typewriters who paraded up and down the aisles like tourists at a fair.

Getting women to overcome their fears of riding elevators was a challenge, however. "We ask as a special favor of ladies who dislike to ride in an elevator

to try ours. The smoothest running elevator we have ever seen; no jerks, no dropping sensation coming down."

The millinery department had its own grand opening on the third floor a few days later. Around this time, the store had a head milliner and from twelve to fifteen assistants who sat at counters all day long making hats. F. Drummond Freese, the son of A. Langdon, recalled many years later that they made three thousand hats a week and had to sell one thousand because fashions changed rapidly. This was back when women wore large hats artfully decorated with flowers, feathers and ribbons.

In the beginning, the store had a marketing region of about a dozen-mile radius. Some years later, the automobile made it possible for people to come from Greenville or Houlton for the day to go shopping and take in a show. Freese's and other Bangor stores could only benefit from these changes.

Over the next few decades, a bewildering succession of expansions and improvements followed those of 1906 and 1907 until the store covered four blocks and consisted of 140,000 square feet, with six stories on Main Street and seven on Pickering Square employing hundreds of people. It became the biggest department store in Northern and Eastern Maine, if not east of Boston, as some claimed.

Today, most of Bangor's early department stores have been forgotten in the wake of the national chains and the shopping malls that finally rearranged the city. But more than twenty-two years after closing on Main Street, Freese's is still a legend.

The old Bangor newspapers captured the spirit over the years. They called Freese's an "industrial colossus" and a "commercial miracle"—even "Fifth Avenue in Maine." By 1957, the expression "Meet me at Freese's" had become as common of a saying in Bangor as "Meet me under the clock in the Biltmore" was in New York City, claimed a *Bangor Daily News* reporter. What Bangor stores will be legends a century from now?

EXCURSIONS WERE A POPULAR SUMMER DIVERSION

July 17, 2006

"Sunday Excursions...Bangor People Are Pining for Cool Trips Out of Town...By Rail and Boat...Trips Down River, to Bar Harbor and Old Orchard and by Electrics to Charleston," announced a four-decker headline in the *Bangor Daily Commercial* on July 14, 1906.

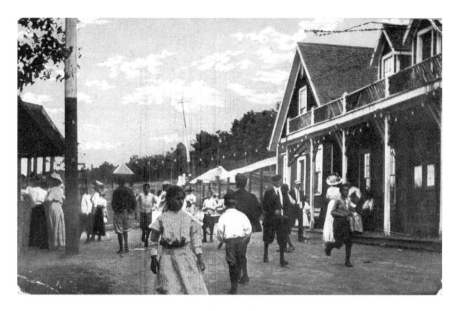

Riverside Park, located near the end of the trolley line in Hampden, was a popular destination for Bangoreans. *Courtesy of Richard R. Shaw.*

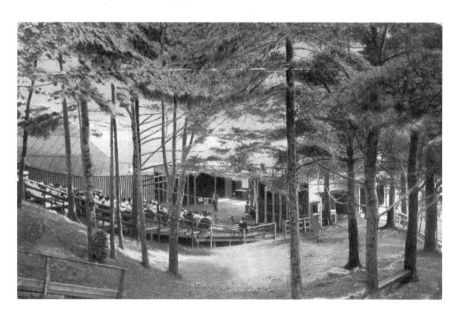

Concerts, plays and vaudeville were performed on the stage next to the Penobscot River at Riverside Park.

For those who couldn't afford a cottage by the seashore or a camp in the woods—and that included just about everybody—an excursion was the next best thing on a hot summer Sunday a century ago. Most employees worked six days a week, so even if they had been able to afford a vacation retreat they wouldn't have had the time to use it. The growing web of mass transportation—steamboats, railroads and electric trolleys—however, placed an excursion within everybody's reach.

On a particular Sunday, restless souls could take the steamer *Bristol* to Islesboro for a shore dinner. Or they could board the steamer *Rockland* for Stockton Springs, where they could view the mammoth B&A Railroad docks and then move on to Northport and Temple Heights. Or they could take a train to Old Orchard Beach or to Mount Desert Ferry in Hancock, where they could pick up a ferry to Bar Harbor to watch the fashionable people parade around. Or, if they just wanted an airy ride out through "the valley of the Kenduskeag," the Bangor Railway & Electric Company was offering special rates on its Bangor & Northern trolley line to Charleston, where riders could get dinner at a hotel.

These were a few of the excursion destinations that summer to which the transportation companies offered lower rates to attract customers. Sometimes social organizations or companies reserved whole train cars or boats. For example, the Orono Pulp and Paper Company at Basin Mills and the International Pulp and Paper Company at Webster chartered the steamer *Bristol* for a Sunday outing to Islesboro later that month, while the Ancient Order of Hibernians in Bangor was planning its twenty-sixth annual outing in August by railroad to Lake Maranacook.

Also in August, the West Penobscot Sunday School Association packed the trolley cars to East Corinth for a picnic at Beech Grove. "The time was filled with amusement: An egg hunt, flag races, bell and hoop contests for girls and boys, nail driving contest for ladies, feeding the animals at noon, a singing contest," said the *Commercial*.

Local amusement parks were also popular destinations. In 1906, there were two in the Bangor area regularly advertising their attractions. Riverside Park in Hampden was operated by the Bangor Railway & Electric Company. It overlooked the Hampden Narrows on the Penobscot River near the site of the present-day Avalon Village. One could travel there by trolley or boat. Amusements included a bowling alley, a dance hall, a merry-go-round, a shooting gallery and alligators displayed in pools, according to Richard M. Newcomb in his history of the park. An open-air theatre featured vaudeville acts, plays, concerts and movies. Attendance rose as high as ten thousand on some summer weekends.

The opener for the 1906 season late in June offered a typical show, including Ward and Raymond, wooden shoe dancers; Mudge and Morton, musical entertainers; Reed's Boston terriers, canine entertainers; Victor LaSalle, comedy acrobat; and Howard and Colby, novelty sketch. Reed's Boston terriers "do everything but talk. If they did talk they would probably have something to say of more consequence than many men," commented a *Bangor Daily News* reviewer.

Opened in 1898, the park closed eighteen years later. According to Newcomb:

> *In 1916, with the advancement of World War I and the availability of automobiles to enjoy new horizons, the park lost attendance and closed. The buildings were destroyed. Today there is no visible sign where the park was in operation.*

The other amusement spot in the area was brand-new in 1906, an offspring of the new Bangor & Aroostook Railroad's Northern Seaport line to Searsport. Penobscot Park was at Bar Point, "midway between Kidder's Point and Mack's Point and directly opposite Sears Island with which it is joined by a bar that is out of water several hours each day," said the *Industrial Journal*. In 1906, the complex included the Bar Point House, which had a veranda all around it, a dance pavilion, a merry-go-round and athletic fields nearby. A shore dinner was served at fifty cents a plate.

Park advertisements promised the "most picturesque spot on the Maine coast." Part of the scene was the big industrial development that the B&A had built around the area in Searsport and Stockton Springs. The view from the park included the Searsport station of the B&A and the new "coal pockets" at Mack's Point, where large vessels were constantly discharging coal for the railroad and the mills of Northern Maine. The *Industrial Journal* noted:

> *At low tide it is an interesting stroll to cross the bar and visit Sears Island... This big island is owned by a syndicate of men prominent in the Bangor & Aroostook Railroad Company and in the not distant future it may be the scene of extensive summer resort developments.*

Penobscot Park closed in 1916. It reopened in 1920 and closed for good seven years later, according to historian Joel Eastman. Most of the B&A's port developments are gone from the area, as well as the dreams for developing Sears Island. But tourists can still enjoy the view and listen for ghostly notes from the old-time merry-go-round that once flourished there.

BANGOR WAS A SHOW TOWN—AND A SPORTING TOWN

EASTERN MAINE STATE FAIR WAS SUMMER HIGHLIGHT

August 1, 2005

Bangor's agricultural fair was an important event in Maine at the beginning of the twentieth century, so its premature burial in the newspapers in 1904 was a major shock.

"Good-By to Bangor's Fair: President Beal Decides to Quit an Unprofitable Enterprise, and There'll Be No More Big Times at Maplewood," announced a headline on July 7, 1904, in the *Bangor Daily News*. "Bangor's famous fair is dead—for this year certainly, and probably for all time," the story declared.

Mayor Flavius O. Beal was one of the city's leading power brokers. He was president of the Eastern Maine State Fair Association and a founder and part owner of the fair. Maplewood Park—later renamed Bass Park—was where the fair was held.

Beal said he was upset because he was losing money. He didn't think local businessmen provided enough support for the event. True to his word, there was no fair in 1904.

But Bangor businessmen weren't about to lose the fair that had brought $1 million into the city since its founding in 1883 and had an average attendance rate of thirty thousand people annually. The next year they put up $3,000 in case the fair was rained out. On May 16, 1905, Beal told the *Bangor Daily News* that the fair would be revived. The mayor said it would be bigger and better than ever.

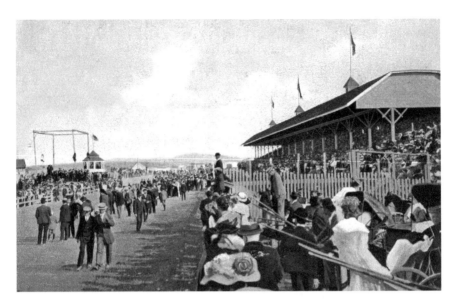

The grandstand at the Eastern Maine State Fair. *Courtesy of Richard R. Shaw.*

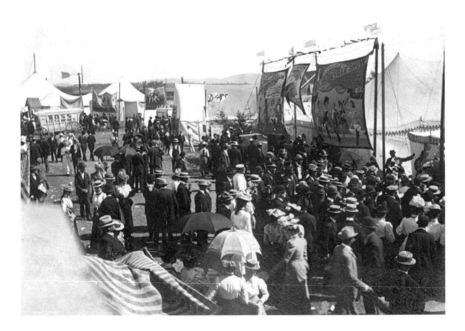

The midway at the Eastern Maine State Fair. *Courtesy of Richard R. Shaw.*

Besides the usual displays of prize farm animals and giant pumpkins and the horse racing that all went hand in hand, the fair would feature Kemp Bros. Hippodrome and Wild West Show with "the greatest rifle shots in existence," the Cody family, not to be confused with Buffalo Bill Cody. The Wild West Show consisted of chariot races, Roman standing bareback races, hurdle races, fancy roping and staged melodramas with titles like "speedy justice to a horse thief [and] genuine cow-boys carrying mail across the plains."

There would also be lots of circus and vaudeville acts, including the Brownie Troop of Bicyclists with their pet dog, Teddy Roosevelt, and "a colored troop of southern artists with plantation songs, cake walking, etc."

Meanwhile, the midway catered to baser tastes. A three-legged chicken and "horses that have human brains" were scheduled. Three "Parisian beauty shows" tantalized young men, delivering little but frustration. In one, a young woman with a surly expression strutted about in a "pink union suit" (long underwear), while in another two young women appeared in pink and white "mosquito netting" and "beautiful brass crowns." There was nothing immoral here! A *Bangor Daily News* reporter cried fraud.

Can the reader imagine a fair without blaring music and treacherous-looking rides whipping through the air? In 1905, the only rides mentioned in the newspaper were two merry-go-rounds, and the Bangor Band was the only source of music.

Electricity was still a novelty for most people. It allowed the fair to stay open late. "Attendees after dark seemed surprised to find the park transformed into an electric city." Fireworks closed each evening.

As the fair opening approached, the *Bangor Daily News* launched a series of editorials urging public officials to clean up the city for the thousands of guests who were coming. No matter how each of these pieces began, they always ended by urging law enforcement officials to do something about the saloons that dotted downtown streets, especially in the vicinity of the waterfront.

"Bangor reeks with dives and dens where liquor is sold. So plenty are these places that a stranger could find them though he were blind or deaf and dumb," an editorial writer harangued on August 25, a few days before the fair opened. A couple of days later the cops raided four "social clubs" on Main and Exchange Streets and in Pickering Square.

The police also went after the "grafters" who wanted to set up their shifty games to prey on the "rubes" who would be flowing in from the countryside. A group of these scam artists who had gone to city hall looking to get some space at the fair were sent instead to see the chief of police. He provided a detachment of cops to escort them down to the steamboat landing for a trip down the coast.

During those four days, August 29 to September 1, a century ago, the crowd came by the thousands, thirty or forty thousand strong. Perhaps as many as five thousand out-of-towners arrived by way of the Bangor & Aroostook and the Maine Central Railroads and the Eastern Steamship Company. Many more came on the trolleys from Old Town, Hampden or Charleston, and still more on small steamers like the *Verona* from places as far away as Deer Isle and Rockland.

And the hostelries—the Bangor House, the Windsor, the St. James, the Alpha and the Penobscot Exchange—were jammed, with cots lined up in the corridors to accommodate the overflow. People could camp out on the fairgrounds in tents if they paid a fee.

The second day of the fair was Governor's Day. Governor William Cobb was driven around the grounds in an automobile, a newsworthy event in itself. That day, the most people packed the fairgrounds since President Theodore Roosevelt had been there three years ago, said the paper. Attendance estimates, however, varied wildly from ten to twenty-five thousand.

When it was all over, reporters for the *Bangor Daily News*, after checking the police logs and visiting the girlie shows, decided that the fair had been "a record breaker for general sobriety and purity." In other words, everyone had a good time except the saloon keepers, the grafters and the young men who had paid to enter the Parisian beauty tents.

BANGOR OPERA HOUSE BROUGHT BROADWAY TO THE QUEEN CITY

June 4, 2007

Bangor was a theatre town much as it was a lumber town, a little Broadway in the Great North Woods. Of course, the lumber paid for the theatres. When plays wore out on the Great White Way, the Queen City provided new audiences, just as Portland and Lewiston did.

On certain evenings in the right season of the year, you were as apt to see Ethel Barrymore or Fay Templeton making their way across Main Street between those two great "houses," the Bangor Opera House and the Bangor House, as you were to see a contingent of red-shirted wood choppers staggering down Exchange Street.

A century ago, the major theatre in town was the Bangor Opera House. That's the Old Bangor Opera House, not to be confused with the New

The Bangor Opera House staged plays, sometimes with the original Broadway casts.

Bangor Opera House, which was built on the same spot on Main Street after the old one burned down in 1914.

Both Bangor newspapers were full of theatre news, local and national. Both papers employed knowledgeable critics with high standards. One of these anonymous critics provided an excellent snapshot of the theatre season on May 28, 1907, in the *Bangor Daily News*. The Bangor Opera House had just closed for the summer.

Theatricals that season could be divided into four categories, according to the writer. They were "the strictly first class, which came originally from Broadway theaters; the better class of 'road shows'; the cheaper class of road shows; and the 10, 20 and 30."

The first two categories—Broadway and the better class of road shows —had featured Ethel Barrymore in *Capt. Jinks of the Horse Marines* and her uncle John Drew in *His House in Order*. Rockland native Maxine Elliott, who was famed for her great beauty, as well as a liaison with J.P. Morgan, had graced the stage in *Her Great Match*.

Shakespeare was popular. Madame Modjeska performed in *Macbeth* and Viola Allen in *Cymbeline*. Two Bernard Shaw plays, *Man and Superman* and *Mrs. Warren's Profession*, also appealed to sophisticated Bangoreans. Meanwhile, musical comedies such as *Piff Paff Pouff* and *The Isle of Bong Bong* helped brighten up the long winter for many, as did *Dockstader's Minstrels*.

But the biggest hit of all—the biggest moneymaker at the box office—was neither Shakespeare nor Shaw, Barrymore nor Elliott. It was Fritzi Scheff in *Mlle. Modiste*, an operetta by Victor Herbert. In fact, the event was the greatest box office draw in the history of the theatre, manager Frank A. Owen told the *Bangor Daily News* writer after the show.

The less said of the other two categories of theatre, the better. "Of the third group—the cheaper one-night stands—the veil of charity should be drawn quickly," said our kindhearted critic.

> *They transcended human belief in badness, but fortunately they were few in number. It is a much-discussed question whether the booby prize should be awarded to "Peck's Bad Boy," "Uncle Josh Spruceby" or "Bertha, the Sewing Machine Girl," although most people will be inclined to give it to the latter.*

Even less was to be said about the "10, 20 and 30 companies," an expression having to do with their low prices. These were repertory companies, which performed several plays, including matinees and evening shows, over several days. For the most part, they were "very coarse and cheap," with a couple of exceptions that rose above the usual "blood-and-thunder plays."

Bangor's newspaper critics fumed that the city was not being treated as well as Portland or Lewiston in either the number of high-quality plays that were being sent here or the number of nights they were allowed to perform. The writer listed several shows Bangoreans had missed that season, including Maude Adams in *Peter Pan*. Some popular shows stayed for only one night, playing to packed houses. Such decisions were made in New York City by a booking agent. Sound familiar?

The writer made no mention of some of the other miscellaneous entertainments that occasionally appeared at the opera house, including moving pictures, hypnotists, comedians, mediums and at least one magnetic healer. Movies were getting more popular, and a recent one had been controversial. *The Unwritten Law* consisted of scenes "representing" incidents and places from the sensational murder of architect Stanford White and the subsequent trial of Harry K. Thaw. A matinee was canceled after a preview on April 11 by the mayor, the chief of police and other officials. Bangor young people didn't need to see that kind of thing. Adults, however, packed two evening showings.

Movies and vaudeville would play a bigger role in Bangor entertainment in the years to come. Rumors had been circulating for months that the Queen City was about to get a new theatre and possibly two. The latest press reports said that John R. Graham, the local trolley magnate, had signed a contract

with the Keith syndicate to start a movie theatre in his new block on Central Street. People would be able to enter the theatre in the morning and watch movies until late at night on one ticket! There were also rumors of plans for "a high-class vaudeville theater." These rumors came true within a year or so.

The Bangor Opera House, then in its twenty-fifth year, was planning major renovations, including increased seating, before opening in the fall. Other theatres with names like the Nickel, the Gaiety, the Graphic and the Gem would soon be opening. Would Bangor remain a theatre town, showing some of the best Broadway fare, or would it switch over to the new forms of entertainment? No one could predict what would happen.

BANGOR'S FIRST MOVIE THEATRE

August 13, 2007

Bangor's first full-time movie theatre, the Nickel, opened at noon on August 12, 1907. Hundreds of people jammed Central Street in an effort to see *A Struggle for Life*, *The Fortune Teller* and *If I Had a Wife Like This*. The papers didn't bother to mention the actors' names, as movie stars hadn't been invented yet. Viewers were usually content if the picture stayed in focus.

In between the movies, illustrated songs were led by Miss Nellie Barron and Grover Lee. Lee was a popular fellow who had just spent the summer singing at Revere Beach. Herbert Ringwall, a local lad, played the piano, and there was "a trap drummer for sound effects." The whole show lasted about forty-five minutes. If you had time on your hands, you could sit through it again on the same nickel that gained you admission.

Peak attendance that first day was at dusk. The next morning, the *Bangor Daily News* reported:

> *Every seat for the first evening entertainment, which began shortly after 7 o'clock, was filled within five minutes after the doors were opened. By eight, a big, good natured, perspiring crowd was jammed before the entrance. It couldn't get in so it waited as patiently as possible for those inside to come out.*

The crowd blocked the street and the sidewalk. Patrolmen Holmes and Smith had their hands full keeping the mob from bursting into the theatre.

"About 8:15 when the first entertainment was over, Central street presented an animated picture—hundreds going in, more hundreds coming out, still

The Nickel, Bangor's first movie theatre, was located on Central Street next to a piano store before the Great Fire of 1911. *Courtesy of Richard R. Shaw.*

other hundreds lined up along the curbing enjoying the fun." The crowd included "many prominent people including Mayor Woodman, practically every member of the city council and numerous heads of city departments." Two days later, a new set of movies opened—*The Sham Beggar, A Kind Grandfather* and *Genevieve of Brabant*—and the crowds appeared again.

The Bangor papers excitedly tried to explain what the new theatre looked like and how it worked in stories in July and August. The color scheme was light green and white. A frieze in white wood, above which was terra cotta, ran around the auditorium. The seven hundred seats were made of veneer with iron arms.

In the foyer, wall panels were finished in "leather relief—the same design, in fact, which has been so greatly admired during the past winter in the ladies' dining room of the Bangor House." A large wooden nickel set in stucco appeared over the ticket booth. A mosaic floor in which the theatre's name was lettered in color still was being installed in the vestibule.

The shallow stage consisted of an archway in the cement wall. In front was hung a heavy, plush, green curtain. Instead of a sheet, the twelve- by fifteen-foot screen was the cement, colored white. Two Powers kinetographs projected the movies, while a double-deck, nickel-plated, dissolving-view stereopticon showed the illustrated songs. "All of this apparatus will be enclosed in a large tin box, absolutely fireproof, inside which the operator will sit," said the *Bangor Daily Commercial* on July 27.

Bangor Was a Show Town—and a Sporting Town

Much was made of the fact that a "motor generator" would convert alternating to direct current, "thus ensuring greater steadiness and brilliance to the picture." The electricity would be supplied by the Bangor Railway & Electric Company's substation on Park Street. Trolley magnate John R. Graham owned the new building where the Nickel was located, and he was also president of the electric company. (The building burned down in the Great Fire of 1911, and Graham built a much taller building next door at the corner of Central and Harlow, where BookMarc's store is located today. The Nickel moved to 99 Union Street.)

People back then were much impressed by electric lights. The new theatre incorporated hundreds of them. There were four chandeliers inside the theatre and many lights outside. The name of the theatre would be in lights out front on the "marquette of glass and iron" over the entrance. The *Bangor Daily News* reported that "the theater will be all ablaze, making upper Central Street as bright as noonday." It would be "Bangor's 'great white way.'"

Security precautions included a deputized doorkeeper, a matron in the ladies' room and three uniformed ushers who were University of Maine students. Modern fire safety features, like an asbestos curtain, were also incorporated.

Eastern Maine was no stranger to movies by 1907. Traveling showmen had been bringing them to Bangor and other towns, where they had been displayed in theatres and public halls for the past several years. Bangor residents had already seen *The Great Train Robbery* at the opera house, along with other movies showing or recreating such events as the assassination of President McKinley.

Bangoreans were proud of the amenities that made their town "a real city." Now, with two theatres (the other being the Bangor Opera House specializing in live stage productions), "Bangor will have arrived at the metropolitan distinction," declared the *Bangor Daily News* on August 12. Indeed, movie theatres were sprouting in cities everywhere. The Nickel was part of a line of Nickels owned by the Keith vaudeville syndicate, including theatres in Manchester, New Hampshire; Biddeford and Portland, Maine; and St. John, Montreal and Halifax, Canada.

The movies were taking Bangor by storm. On September 21, the *Bangor Daily News* announced that another theatre would be opening soon. The Bangor Amusement and Bowling Company planned to remodel Union Hall at 99 Union Street, leaving the bowling alleys and poolroom and creating a second floor. Vaudeville and moving pictures would be shown. "Bangor is hungering for entertainment of the best sort," the financial backers had determined.

ROLLER-SKATING CRAZE HELPED FINANCE OPERA

September 12, 2005

Bangoreans turned out one thousand strong to launch the great roller-skating craze of 1905. On a chilly May evening, most sat as spectators while a courageous few careened around a floor "smooth as polished glass" to martial music. Blazing electric lights illuminated the far corners of the cavernous Bangor Auditorium, where people were more used to hearing opera arias than the clicketyclack of roller skates.

Built in 1897, the huge auditorium—not to be confused with the current one—had hosted lavish opera extravaganzas starring such internationally famous divas as Maine's own Madame Nordica. Now, much to the surprise of some, the *Bangor Daily News* said on May 22 that the building was going to be, at least for the time being, New England's biggest roller-skating rink.

L.D. Mathis, who ran a rink in Portland, promised that a blazing sign would stretch across the front of the building, "turning night into day," and more electric lights would festoon the entrance. Soon there would be a new $500 floor installed.

While hundreds of spectators looked on that opening night, the Brewer Band set the tempo, while a few dozen young men summoned

The Bangor Auditorium, the Queen City's "opera temple." *Courtesy of Richard R. Shaw.*

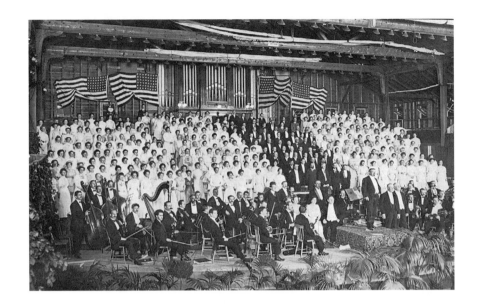

Above: Many world-famous opera stars appeared at the Maine Music Festival each fall at the Bangor Auditorium. *Courtesy of Richard R. Shaw.*

Right: Roller-skating champs. *Courtesy of Richard R. Shaw.*

the courage to try out the sport that had been dormant in the area for several years.

It was not until exactly 9:30 p.m. that the first young woman "tempted fate," said the newspaper. "She was gowned in a neat-fitting dress of blue serge, wore her hair in an enormous pompadour, and skated with an easy grace." Several other women followed, but most were content to sit in the balcony with their male companions either until it was proved that roller-skating was a ladylike pastime or perhaps until they had a skating lesson or two.

The Bangor Auditorium sat near the corner of Main and Buck Streets in front of where the current auditorium is located today. It had been built for the use of the Maine Music Festival, the apex of the Queen City's musical history. At 175 feet long and 82 feet wide, the wooden, barnlike structure had a seating capacity of between four and five thousand.

Some people were taken aback at the idea that "Bangor's cherished temple of music" would be used for roller-skating. The reintroduction of the sport in 1905, however, was a way to help pay the festival's debts, a *BDN* story explained on June 17. "Money—that is the whole story. It was merely another instance of commercialism coming to the aid of art," reported the newspaper.

As the spring progressed, the new rink began to sponsor races in which ambitious young men from all over the state competed for monetary awards. In the first such event, a five-mile contest on June 9, William O'Brien of Portland defeated one Canning, no address given. Bangor's hero, Jimmie Conners, placed third, while the fourth contestant, Fred Vesser of Houlton, fell down several times and dropped out. Later that month, Conners defeated a field of nine other contestants.

It was hard to tell who Bangor liked better—roller-skating champs or opera stars. Late in July, the best-attended race to date occurred. Fred O. Follis of Eastport defeated Portland's O'Brien in the three-mile contest. The paper described it as the largest crowd to attend an event at the auditorium since 1903, when Madame Schumann-Heink, the opera diva, sang at the Maine Festival. In August, O'Brien, who had moved to Bangor by then, defeated Follis to reclaim his title.

One of the grandest events of the season, the Great Masquerade Skating Carnival, occurred on September 27. More than one thousand spectators turned out to watch Indians, princesses, court jesters, cowboys, Mexicans, flower girls, queens, the Goddess of Liberty and "all the funny characters made famous by the New York papers" circle the arena. Miss Mattie Bissette, attired as the "Fencing Girl," took the first prize, a solid silver fruit dish, while Hiram Pelham, dressed as Louis XVI, won second, a silver smoking set. A censor stood at the door to make sure no "objectionable characters" entered the rink.

Roller-skating had existed in Bangor sporadically since the early 1880s, according to Donald J. King in his University of Maine master's thesis on leisure-time activities in the Queen City. Short-lived rinks had been opened at various times at Bangor City Hall, Norombega Hall and Union Hall. Marathon events, such as a twenty-four-hour, 232-mile ordeal held one season at Union Hall, were introduced to boost attendance. The pastime also lent itself to team sports. During much of this period, roller polo teams with names like the Norombegas and the Resolutes represented Bangor.

All these buildings—the old Bangor Auditorium, the old Norombega Hall (the early one where Norumbega Parkway is today), Bangor City Hall (at Hammond and Columbia Streets) and Union Hall—are gone, the victims of fires or the wrecking ball. I could not visit any of these recreational mausoleums to imagine I heard the crowd's roar and the rumble of wooden wheels echoing off the dingy walls. Of course, there are modern rinks, at least two in Bangor, but in my mind's eye they couldn't have equaled the hallowed spots where O'Brien, Follis, Conners and others made the floorboards sizzle once upon a time.

This was a sport, after all, that could turn a reporter into a poet. As one newspaper scribe wrote in the *Bangor Daily News* a century ago:

> *Did you ever have on roller skates? Earth, sky and air appear to melt away; the blood runs fire in the veins; and then—and then if you are young and foolish it is just possible you may see more stars than ever the* [Music] *festival boasted in its palmiest days.*

BANGOR WON THE PENNANT…
WITH OLD SOCK'S HELP

September 10, 2007

Bangor won the pennant a century ago. Baseball fans were jubilant. It didn't matter that only four teams were still in the Maine League and only two of them had participated the whole season. Nor did it matter that the entire Bangor team had been fired and replaced. All that mattered was that Bangor had beaten its arch rival. "The Queen City of the East has fairly and unquestionably won the baseball championship of Maine. We have beaten our dearest rival, Portland, to a frazzle," declared the *Bangor Daily News* on September 2, 1907.

Small-town semiprofessional baseball had its ups and downs. The *Bangor Daily Commercial* declared the local game "practically dead" at the end of

Above: Bangor's baseball team won the state pennant in 1907. Louis Sockalexis is the last player seated on the left in the front row on the ground. *Courtesy of Richard R. Shaw.*

Left: Louis Sockalexis. *Courtesy of the Bangor Daily News.*

1905. "Ten years ago Bangor was leading the clubs of the New England league and was one of the hottest baseball towns in the country," lamented the reporter. That was when "The Millionaires," nicknamed for the wealthy boosters who financed them, took the New England title in 1896.

In 1907, a new visionary, Fred Paige, arrived to start up a Bangor baseball team "on a business basis." Paige planned to spend about $600 of his own money to rebuild the diamond at Maplewood Park (Bass Park today) and buy spiffy white and maroon uniforms like the Millionaires', reported the *Bangor Daily News* on March 27.

You can't help but have a warm spot in your heart for Paige. He let small boys into the games for free. "To make any show of keeping them out I'd have to hire a dozen policemen," the grizzled baseball promoter told the "About Town" columnist at the *Bangor Daily News* on June 17.

He also let a "clever girl" show her stuff. Miss Marion Reynolds was "a bright little blonde" from Brooks who could catch "just like a boy." During fifteen minutes she was allotted before the game on July 3, she caught fly balls "as easy as eating ice cream" and fielded grounders, returning them with an easy "whip which was pretty to see," according to the account in the *Bangor Daily News*.

Paige said he had received more than one hundred applications for the team. The signing of players became a hot news item. One was Henry Mitchell of Indian Island. He had played ball for the Carlisle Indian School in Pennsylvania. He was purported to be "the most promising Indian player since the days of the great Sockalexis," said the *Bangor Daily News* on March 22.

Then "Old Sock" himself showed up, much to everyone's surprise and delight. At age thirty-five, the legendary slugger and outfielder was trying once again to regain the baseball career he had squandered in the big leagues through heavy drinking.

Paige said he thought Sockalexis's application was an April Fool's joke. Then he tried him out. "Outside of a little surplus fat he was sound in wind and limb and no trace of rheumatism," reported the *Bangor Daily News* on April 2. "He is by no means an old man although many people get that impression because he is called 'Old Sock.' I believe he is worth taking a chance on anyway," Paige told the newspaper. "If he doesn't make good, it's back to Old Town for him."

Louis Sockalexis was a crowd pleaser. "Bangor fans would be mightily pleased to see old Sock swing his great war club as in days of yore and lambaste the leather over the standpipe," wrote the always enthusiastic reporter. Sure enough, the fans cheered heartily when he made an appearance in the field or at bat. With Sockalexis and Mitchell onboard, the *Bangor Daily Commercial* nicknamed the team the Indians and the Braves, at least for a few weeks.

The season got going slowly. Late in May, the Bangor boys played the Philadelphia Giants, a champion black team that kept up a humorous patter while slaughtering the opposition. The papers were full of racist commentary, but the *Commercial*'s reporter pointed out on May 21 that "it was one of the cases when the white man's boasted superiority was not apparent."

Before that, Bangor had suffered humiliating defeats at the hands of the University of Maine and Higgins Classical Institute. Paige told a *Bangor Daily News* reporter on May 16 that he was "disgusted but not discouraged. The sooner I find out what there is in this bunch the better. I am going to order in four more men who are said to be wonders and ship the most of this lot home." In the days ahead, such Maine stars as George Edward "Chummy" Gray of Rockland and Fred John "Biddo" Iott of Houlton were among those signed.

After Maine League games got underway on May 24, Bangor gained supremacy. By June 17, the team had won eleven of fifteen games against competitors Lewiston, Augusta, Waterville, Portland and Manchester, New Hampshire. "Never in the history of Bangor baseball has a team representing the city made such a good showing in competition with other cities in the state," said the *Bangor Daily News*.

A story in the *Commercial* the same day, however, revealed a crisis. The team was $300 in debt, and Paige was looking for ways to raise money. Also, Old Sock had been suspended on account of "indifferent playing." Sockalexis had made some good plays and nailed some hits. He had lasted longer than almost all of the other members of the original team.

The crisis was settled on July 5 with the formation of the Bangor Baseball Association, a stock company of fifty or more members. Directors were ex-mayor Charles F. Bragg as president, along with Mayor John F. Woodman, C.A. Fowler, W.H. Rollins, J.H. Rice, C.A. Robbins, D.F. Webster, James F. Singleton and A. Langdon Freese. Paige was hired as manager on a salary, but Iott, who had already emerged as the team's captain, soon replaced him.

As the summer passed, the league was down to only four teams—Bangor, Biddeford, Portland and South Portland. But the real news was that for the first time in history, the Maine League had lasted through the season, said the papers.

"We Nail Pennant to Mast-Head," declared the *Bangor Daily News* on September 3 after the team took two from Biddeford. Bangor had won forty-seven games and lost thirty-one. Fred Iott was the city's newest hero.

There was talk of plans for next year—that all the Bangor players wanted to come back, that Old Town and Rockland were going to join the league, that a new diamond would be built somewhere other than the unsatisfactory Maplewood Park. The sky was the limit.

BAD BANGOR

Bangoreans Couldn't Stop Liquor Flow— Even When They Tried

June 20, 2005

Penobscot County's "campaign for purity" had been going on for six long months by the afternoon of June 8, 1905, when a squad of Bangor cops raided the Mexican Chile. It was only 5:30 p.m. on Thursday, but things were already jumping at the Broad Street bar in the heart of the Queen City's saloon district.

The latest effort by local Republicans to enforce state prohibition seemed an exercise in futility if the Chile was any indicator. Twenty-two customers, including six young women "with beautiful golden hair—black at the roots," were arrested. So was the owner, James Cyr, who, it was alleged, traveled from city to city setting up similar "resorts."

With a huge palm tree gracing the center of the barroom and lots of locked rooms upstairs for extracurricular activity, the Chile was a sophisticated operation that would have been known as "a cheap palm garden" or "a low beer or smoking parlor" had it been located in a big city. In the Queen City, it was simply tagged "Bangor's most vicious den of iniquity" and "the wickedest resort east of Boston" by the *Bangor Daily News*.

The squad of cops hid in the shadows while Patrolman Clark, in plain clothes, talked his way into the building. An ingenious mechanical contrivance behind the bar enabled the barkeep to lock and unlock the front door from

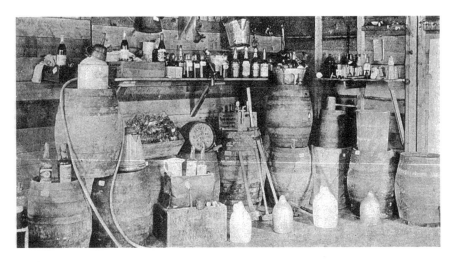

Sturgis deputies stored liquor they seized in Bangor raids in this room on Franklin Street. *Courtesy of Richard R. Shaw.*

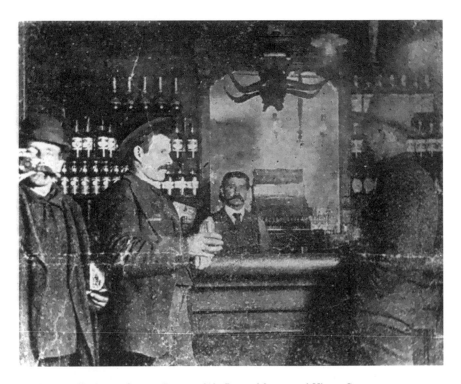

A saloon on Exchange Street. *Courtesy of the Bangor Museum and History Center.*

behind the bar. The dousing of the Chile was proof that, despite all the tough talk about liquor enforcement during the past six months, "no deaths from raging thirsts" had occurred, wrote a reporter.

The Chile raid was one of hundreds by local officials all over Maine seeking to neutralize the Sturgis Commission, the new Republican-inspired law enforcement agency that would be up and running soon with authority to enter a town uninvited to enforce prohibition if locals fell down on the job. Governor William Cobb had signed the bill late in March and appointed the three commissioners early in April. The draconian measure had been instituted because many local officials, including many Republicans, supported Maine's prohibition law, which was the oldest state law banning booze in the country—in name only.

The surge in raids had started in January after a new, ambitious county attorney declared that there were 250 liquor dealers in Bangor, and he was going to send them all to jail. One of the joints to bite the dust first was the Busy Bee, whose "gorgeous ultramarine blue front" faced Haymarket Square, a short distance down Broad Street from the Mexican Chile.

The police were thorough. Besides taking Alexander MacDonald's liquor supply, they disassembled the bar, removed the mirrors from the walls, ripped up the velvet carpets and even carried off busts of Shakespeare and Dante. A delighted reporter waxed poetic on March 31:

> *How did the little Busy Bee*
> *Improve each shining minute*
> *By dishing out the eau de gee*
> *For what there might be in it;*
> *To sidestep Sturgis and the cops*
> *It was the Bee's delight—*
> *To busy be while other shops*
> *Were dark and closed up tight.*

As the liquor crusade continued, Boston suppliers complained in an April 3 story in the *Bangor Daily News* that they couldn't collect an estimated half million dollars in debts owed by Maine dealers. Meanwhile, hotel owners groused on April 13 that they would have to raise their rates if they couldn't sell liquor to their customers.

"People come here from all over the world, and many of them call for liquor on the table, in their rooms or at the bar," said Captain Horace Chapman, proprietor of the Bangor House, the Queen City's leading hotel. If they don't

get served in the hotel, "they send out or go out and buy it somewhere in Bangor—and they apparently have no difficulty in getting what they want."

As the days went by, zealous law enforcement officers even raided express offices in search of mail-order booze. The results were sometimes surprising. A May 11 *BDN* editorial read:

> *Here are highly respectable men who have preached temperance all their lives and who have condemned the use of liquor in any form, hauled to court and compelled to testify that the contents of the bottles addressed to them were for their own personal use.*

Even druggists and other people handling liquor-laced patent medicines were at risk, including nineteen indicted in Biddeford in one swoop. But the strangest event occurred on April 5, when the Knox County Sheriff's Department raided the City of Rockland's liquor agency, where booze could be bought legally with a doctor's prescription, and seized the entire stock. Then the sheriff and his four deputies seized large amounts of patent medicine containing alcohol from two wholesale houses, one of which —Cobb, Wight & Company—belonged to Governor Cobb.

But were all the raids accomplishing much? The *Bangor Daily News*, a Republican newspaper that supported the Sturgis Commission, was growing increasingly skeptical.

On April 4, three months after the current round of raids began, a *Bangor Daily News* reporter estimated that there were still forty to sixty places to buy liquor in Bangor. These included "back-door businesses" and "kitchen barrooms" run by women. "Pocket peddlers" cruised the streets taking orders. The "pitcher plan" was also popular. Bartenders kept the goods in glass pitchers that they could smash in the sink and wash down the drain in a hurry during a raid.

A few days later, the police made one of the biggest raids in the city's history, confiscating $2,500 worth of liquor—111 bottles and 6 barrels of whiskey and 935 bottles of beer—in a stable on Adams Street, allegedly intended for the Globe Hotel.

Surprised by all the drunks in court one morning, a reporter asked a police officer how the liquor campaign was going. "Well, it's very simple," said the cop.

> *All the cheap places in town are selling and making big money and all the "good" places are closed up. Down in the [Devil's Half] acre and along*

Broad Street and even on the other side [of Kenduskeag Stream] *at the foot of Exchange Street and through the district of lumbermen's boarding houses the bars are running full blast.*

A week before the raid on the Mexican Chile, a *Bangor Daily News* editorial questioned whether the members of the Sturgis Commission were doing anything to justify their annual $1,500 salaries. "Just now there are coming to us from all parts of the state many loud complaints about the utter inefficiency of the Sturgis Commission," said the writer.

All he had to do was wait for the other shoe to drop. On June 26, the paper announced on page one that three Sturgis deputies had started conducting raids in Lewiston, the city long rumored to be the commission's first target.

Two days later, one of the commissioners, Alfred H. Lang, former sheriff of Somerset County, paid a visit to Bangor. After talking to the sheriff and the police, he took a walk through the saloon district—down Exchange Street, across the drawbridge, up Broad Street and through Pickering Square.

The reporter wrote:

He didn't appear to be taking any special interest in the places which might have been doing business along the route but it is safe to wager that he had his eyes open. The lookouts posted at some of the places did not recognize him—if they had there'd been some bad cases of hysteria and heart disease.

He predicted that "sweeping indictments" would soon be issued locally in an effort to ward off the Sturgis sting that everyone knew was coming.

THE BAD GIRLS OF HARLOW STREET

March 10, 2008

Harlow Street was Bangor's red-light district a century ago. Of course, there were plenty of other places where loose women mixed well with liquor and lonely men. One was the Pilgrim Chambers, conveniently located on Hammond Street just above the YMCA. One Celeste presided over affairs, dressed in a magnificent flowing gown of robin's egg blue satin with tin diamonds. But there was something special about Harlow Street. Now in her late seventies, Fan Jones, the famous harlot of Harlow Street, had most likely

Bangor High School was in Abbott Square on Harlow Street before it burned down in the Great Fire of 1911. *Courtesy of Richard R. Shaw.*

retired, but she still lived at the corner of Harlow and Cumberland. She was a symbol of what was left of the old Bangor, when vice went hand in hand with the city's famed lumber economy and the fun-loving loggers and sailors who kept it going.

All the frolicking on Harlow Street was on a collision course with the new Bangor, the place where respectable families wanted a well-regulated moral atmosphere in which to raise their children. Bangor High School also happened to be located on Harlow Street, in Abbott Square, which is a parking lot today across from the Bangor Public Library. The keepers of the public's morals launched a campaign to clean up the area so high school students wouldn't be exposed to vice.

For example, Chief of Police Bowen and four underlings sat in the parlor of the Columbia House on Harlow Street for half of one August night in 1907, methodically apprehending five johns as they walked through the door. They also arrested six young women and the proprietor, William I. Jackson.

The nearby Fiske building seemed to contain several "houses of ill fame," operating all at once in various rooms and apartments, press reports indicated. But the most notorious of these Harlow Street establishments at this time was the Glenwood Hotel, a boardinghouse located at the corner of Spring Street a few doors down from Fan Jones's house.

The Glenwood and the adjoining Fiske building first made a splash in the papers on August 30, 1907. Twenty state liquor agents, better known then as Sturgis deputies, had staged a spectacular raid late the night before. "A great crowd showered suggestions and advice," commented the *Bangor Daily*

News. "For an hour they remained there, the crowd constantly swelling and until late into the night the tenderloin was in a turmoil…Hundreds from the theaters streamed up and filled the street and sidewalks from curb to curb."

The lights were out in "the long row of buildings" as the twenty agents approached from all sides. Breaking up into squads, they splintered doors and broke glass. They worked with businesslike precision "to the accompaniment of hysterical laughter, smothered screams and the muttered curses of male voices," reported the newspaper. "Lights began to flash throughout the buildings, and white-gowned feminine figures flittered before the windows to the edification of a gaping crowd in the street below."

The saga of the Glenwood Hotel broke into the newspapers again that winter with the trial of the proprietor, William I. Gerry (or Gary), for maintaining a public nuisance. The courtroom and the corridors outside were packed to capacity, reported the *Bangor Daily News* on February 13, 1908. The headline read, "Conditions Bad in Harlow Street."

"The state is the complainant in this case," County Attorney Hervey Patten lectured the jury.

> *Let me tell you that every citizen of Bangor who sends his children to the High School is a complainant also. We want you to help us clean certain places out…We don't want the street through which our children daily pass to reek with corruption. And with your help we will not stop until we have abolished every vicious resort in the vicinity.*

One witness—a police officer whose beat was Harlow Street—said that men went into the Glenwood sober and came out drunk. Women entered at all hours of the night and congregated around the door. On cross-examination, however, he could not name a single complaint that had been filed about activities at the hotel.

A former boarder, Mrs. Annie Welch, testified that defendant Gerry sold liquor from a teapot that he kept in his room. She and another former boarder "told in some detail of the style of living there." Doubtlessly, this testimony contained the lurid details of the illicit sex trade, the stuff the newspapers never printed. For all their brashness, newspapers were prudish when it came to sexual matters back then, filling their columns with euphemisms and sly innuendo instead. As one *Bangor Daily News* reporter wrote in covering another whore-house trial, "The cases were redolent as it were of testimony which for obvious reasons will not be published, although the gallery seemed to relish the proceedings."

The *Bangor Daily News* praised Patten for his crusade to clean up Harlow Street. An editorial on the morning of February 24 read:

> *Children learn the aspects of sin in all its cruel and beastly deformity soon enough without having object lessons in evil ways stuck right under their eyes every time they emerge from the school building...Perhaps this particular resort is no worse than some others in and near Bangor, but most of the dives of this nature have the saving grace of trying to conceal their shame.*

That same morning, W.I. Gerry was fined $620 and sentenced to six months in jail for keeping a house of ill fame. A year later, he was working as a teamster, according to the city directory. Many others were standing in line to take his place, however. Madam Fan's take on the matter is nowhere recorded.

WHEN SLOT MACHINES DISPENSED CIGARS

November 14, 2005

Back when Las Vegas was just a dot in the desert and Hollywood was a good place to grow bananas, you could put a nickel in a slot machine in Bangor, Maine, and win fifty cigars. Storm clouds were gathering on the horizon, however, as the county attorney's "campaign for purity" got underway. Like selling liquor, gambling was illegal, and the forces of virtue were on the march.

When Penobscot County's new county attorney, Hervey Patten, was asked by a reporter on January 1, 1905, if his campaign included gambling, he replied:

> *Yes, slot machines, gambling houses and everything must go. I will clean them out. The county is alive with the slot machines into which many men and even boys dump their entire earnings while their families suffer for the necessities of life. It is a curse which has endured altogether too long.*

A particularly thorny issue was what to do about slot machines that dispensed cigars instead of money. Were they gambling machines? A player would put a nickel in the slot and get at least one cigar back. He could win up to fifty depending on what "hand" came up on the cylinder that rotated

on a shaft, each of its five sections showing a picture of a different playing card. The campaign for purity won a victory that winter when the Maine Supreme Court ruled in a Skowhegan case that these cigar machines were gambling devices. The *Bangor Daily News* declared the ruling "a death blow to slot machines" on February 23.

But the real "death blow" in the Queen City, at least temporarily, occurred on March 31, when state detective Dennis Tracey issued a declaration of war on the gamblers. He told a reporter that the city was "full of slot machines and gambling of all kinds." His notice was printed in the papers on April Fool's Day, but it was no joke to the many owners of stores and taverns who kept slots on the premises.

The move came in response to a new law passed just days earlier enabling enforcement officers to arrest individuals for merely being in the presence of gambling equipment. Before that, the police could only arrest people who were actually gambling "and this was no easy thing to do when heavy doors had to be broken in to obtain entrance," reported the *Bangor Daily News*.

Back then, the newspaper's police reporter was a bard as well as a scribe. The promise of police raids stimulated his creative juices, and he wrote poems to accompany his stories. On April 3, 1905, even the headline rhymed: "Upon the Slot the Lid is Down, Thus Tracey Purifies the Town."

The lead was the following bit of doggerel, doubtlessly read to the tune of laughter in dozens of living rooms around the city, and a few barrooms as well.

> *Oh! Have you yet a nickel remaining in your jeans?*
> *If so, go buy a hot dog or else a plate of beans.*
> *For you cannot sink that nickel by the old time wicked means—*
> *For Tracey's put the slot machines in mourning.*
> *Yes, he's sounded the alarm and they've stowed the things away.*
> *In the cellars and the attics, and he swears that there they'll stay;*
> *He says, "We'll try the simple life—this town has been too gay."*
> *So they quit on April Fool's day in the morning.*

The reporter wrote:

> *It is said that when the proclamation was issued there were anywhere from 50 to 100 slot machines running in Bangor, but whatever the number, on Saturday night not a wheel was turning, not a slot yawned for nickels.*

But did they really need to eliminate the harmless cigar machines? "To order them out was nothing short of blue-law despotism, the last extremity of fanaticism, uncalled for and altogether unnecessary," sputtered this reportorial bard. It is unclear whether these were his views or those of the inebriated sources he encountered on Saturday night.

Were he here today to observe the return of slot machines to Bangor—the merger of Hollywood, Las Vegas and the Queen City—I wonder what poetic reveries this old-time reporter would be pounding out on his blackened Royal, a cigar clenched between his teeth, as he struggled to control his laughter.

THE SEARCH FOR MINOT ST. CLAIR FRANCIS

November 27, 2006

One late November afternoon in 1906, an inmate with the unlikely name of Minot St. Clair Francis bolted from a work detail, sprinted across the Maine State Prison yard at Thomaston, scaled the wall and disappeared into the darkness of the nearby woods, bullets whistling about him. During the next two weeks, his disappearance turned into the state's most celebrated manhunt, both Bangor newspapers agreed.

Journalistic accounts of the ensuing events, however, degenerated into a frustrating stew of gossip, speculation, bravado and hysteria. There was little or no agreement on whether Francis was armed or unarmed, dangerous or merely desperate, tall or short, burly or fat, headed for Bath or Bangor and so on. Revelations that he was a poet and an artist contradicted the prevailing image of a hardened thug. Some people started to root for him and against his inept pursuers.

The newspapers seemed to agree on only two things. One was that Francis was a lot smarter than the hundreds of people who were trying to find him. The second was the color of his skin. Francis was an African American. He was referred to repeatedly as a "Negro [or colored] desperado" in virtually every story that appeared. There were some doubts, however, about his exact DNA makeup—it was explained that he was a mulatto who could pass for a white man at a distance with his hat pulled low on his forehead.

While Francis was on the loose, a dark-skinned person was apt to be accosted on a downtown street or shot at in the woods by someone hoping to gain the $200 in reward money. The *Commercial* ran the following headline on

November 20, 1906: "Colored Man Seen on Washington Street Tuesday… All Strangers of Dusky Hue Are Closely Scrutinized These Days—Officials Are Watchful." Other blacks, Indians, at least one Italian and even the "dark-skinned" sheriff of Waldo County had narrow escapes with overzealous pursuers. One victim filed a lawsuit against the prison warden after he was accidentally shot in Rockport during the chase.

When Francis escaped on November 12, fear gripped the countryside because of his imagined savagery. "Every Farmer from Penobscot to Plymouth on Guard," announced a *Commercial* headline on November 23. The story read:

> *Through the dark hours Thursday many a clump of bushes down in Newburgh concealed a youth wrapped in his greatcoat and armed with rifle or shotgun…Every shadow was to them a negro armed to the teeth, with bloodshot eyes and haggard face, desperate determined, ready to kill any who should bar his path.*

Minot St. Clair Francis, age twenty-six, and another man had been sentenced to the Maine State Prison in February for shooting and wounding a night watchman while breaking into the post office at Red Beach, a village in Calais. Francis was already on the lam from a Massachusetts correctional facility when arrested for the Red Beach crime. He had previous convictions for larceny and assault.

In the first few days after his escape, newspaper accounts described him as going in two directions at once—either toward Bath, where a militia company turned out to comb the banks of the Kennebec River, or toward Bangor. Newspapers in Waterville, Lewiston and St. John, New Brunswick, also ran stories claiming that people had spotted him near those locales. Cornered in Rockport and again, a week later, in Monroe, he eluded his pursuers, who often had no idea where he was. Many crimes were attributed to him—from stealing horses to pilfering a pot of beans.

Jokes, some racist, began appearing in the newspapers. One Bangor wit, tobacconist A. Lewis, ran a large pipe advertisement in the *Bangor Daily News*, suggesting that Francis might be hiding in his cellar at 26 State Street: "Mr. Minot St. Clair Francis, late of Thomaston…is at this minute in Bath, Rockland, Damariscotta, Arrowsic, Bethel, Lincolnville, Veazie, Razorville and Oshkosh, Wis. and some other places," it said.

The big break in the case came after Francis stole a team in Prospect and drove up the road through downtown Bangor in the middle of the night.

He spent the next day in a shed. Then he set out on foot toward Glenburn, where he holed up in a hay barn belonging to A.L. Grover on November 28. Several farm workers discovered him. Mrs. Grover prepared him breakfast, sending her son to a nearby telegraph office to notify authorities in Bangor. Admitting who he was, Francis appeared to have given up.

As he was being arrested in the hay loft without resistance, he "looked at his captives and cried, with a note of agony and despair in his voice: 'For God's sake, why didn't you shoot me before this,'" wrote a *Bangor Daily News* reporter. Francis had no gun. In fact, the convict was freezing and starving, and his feet were badly injured. After witnessing the event, the disgusted reporter wrote contemptuously, "It was a victory of the powerful forces of the law—many well-armed, strong and well fed men, over a hunted convict, half starved, unarmed, penniless and scarcely able to stand."

As interest in the case waned, some newsmen wanted to set the record straight. On December 1, a reporter for the *Bangor Daily News* wrote:

> *The most vivid impression remaining in the public mind is that never in the history of grand-stand playing and all around four-flushing was there a more ridiculous performance than the attempt of several of the pursuing army to get reputations…by representing Francis to be a second Jesse James.*

An editorial writer on the same day went a step further:

> *Instead of being "a negro fiend," such as certain newspapers have pictured him to be, Francis seems to have treated the country…with marked consideration. For these acts of restraint he should receive due credit.*

The Great Crime Wave of 1906

July 24, 2006

During the long, hot summer of 1906, Bangor became the crime center of the nation, perhaps of the world, at least in the fevered imaginations of reporters and editors at the *Bangor Daily Commercial*, the city's afternoon newspaper. "Many Crooks Here…Bangor is Pretty Nearly as Badly Off as Chicago Now…Hoboes Are Insolent," announced a multi-decker headline on July 17.

Exchange Street, located in the heart of the saloon district, was the scene of much public drunkenness and brawling. *Courtesy of Richard R. Shaw.*

Hoboes, yeggmen, pickpockets, muggers, con artists, robbers and a host of other bad guys had been gathering in the Queen City since sometime in the spring. There were more tough characters hanging around than ever before, according to an informed source, "who has seen as much of the so-called slums of Bangor as anybody living outside and knows enough about the men who make their headquarters here to know a crook or a thug when he sees one." The reporter advised:

> *One only has to take a walk through the section of the city known as the "Devil's Half-Acre," through the railroad yards and up along the river front from Washington street to Foley shore below the Eastern Maine General hospital to satisfy himself of the number of these tough characters in the city.*

Yet after setting the stage so well, the reporter admitted that there had not been a single murder, bank robbery or anything else really serious. He seemed mostly concerned with the hoboes, that mysterious infestation of rootless men that bloomed like algae along the riverfront on the borders of the city's most exclusive neighborhoods each summer.

Housewives had been scared out of their wits by villainous looking individuals knocking at their kitchen doors looking for handouts. And just

the other night, two young men "well known in society" had to employ a horse whip both on the horses and on intruding thugs—probably hoboes—to prevent being held up as they traveled by carriage with their wives just below the Tin Bridge over the line in Hampden.

The papers had printed a few crime reports that spring and summer, but little that was particularly unusual. In what was probably the most lucrative heist in years, Cliff Cottage, the famous home of Mrs. George Fred Godfrey perched high over the Kenduskeag Stream, was robbed of a small fortune in jewelry on May 28. A fifty-dollar reward was offered for the return of a topaz set. Pieces made of gold, silver, diamonds and other precious stones were also taken, according to an inventory published in the *Commercial* on June 23.

More typical was the mugging of John Hobbs of Springfield. He had been introduced by Sammy Blue to Mattie Daley, better known around Bangor as Mattie Foster. They went to "a resort" on Hodgdon Street, where they rented a room for fifty cents. Hobbs said he had one drink of whiskey and woke up about an hour later to discover he had been relieved of $175. "Hobbs says he is unsophisticated in the wicked ways of Bangor and he looks the part," declared the *Commercial* on July 18.

One of the benefits of living in a city with two newspapers was that there were often two sides to a story. The *Bangor Daily News* was always ready to correct the *Commercial*'s tendency to overdramatize the facts, and vice versa.

"Morning! Been Held Up Yet?" clamored the headline in the *Bangor Daily News* on the day after the *Commercial*'s story comparing Bangor's crime rate to Chicago's.

> *The Bangor police and other persons in a position to really know are very much amused and not a little indignant at an afternoon paper's assertion that Bangor is now harboring in proportion to its size more tramps, crooks and thugs than Chicago—the most notoriously wicked city on the continent. Truly, we are getting more metropolitan every day!*

The city was safe. People "may visit the 'Devil's Half-Acre' or even the water front without being sandbagged or robbed or shot or stabbed or poisoned." The *Commercial* was confusing begging and drunkenness with real crimes, scoffed the rival reporter.

Nevertheless, both newspapers continued to report the many minor crimes in the great metropolis. The circus, always a magnet for petty thieves and bunco artists, came to town the next day. Several pockets were picked, and

some suspicious games of chance were closed down by the police. A man was shoved off the platform of a moving train after being relieved of fifteen dollars. Twenty-nine individuals, including twenty drunks, were locked up at the police station.

One of the most interesting crime stories of the summer, however, was more appropriate to a Norman Rockwell painting than to the lurid pulp magazines that documented heinous acts in Chicago. "Those Horrid Boys... They Go Swimming Without Bathing Trunks Again...Police Are Shocked," declared a playful headline on July 20 in the *Commercial*.

The two most popular swimming spots in the area on the Penobscot River were the Brewer sandbank and the Bangor lumber docks directly across from each other just above the railroad bridge. Youngsters had learned to swim there from time immemorial. Not anymore. A new class of boaters was making things difficult.

A *Commercial* reporter related:

> *For several days past the telephone bell in the police guard room has been jingling merrily and the officers have been dancing a lively tune in answer to requests to send a policeman up to the sandbank or the lumber docks to drive away some small boys or others who have offended somebody's modesty by daring to go in swimming in the garb with which nature has provided them.*

Bangor has recorded some ghastly crimes in its history, but not that summer. Soon the hoboes would be disappearing down the tracks like the autumn leaves, and boys would be returning to school.

ILLNESS AND FIRE:
THREATS TO PUBLIC HEALTH

POLLUTED DRINKING WATER CAUSED TYPHOID
EPIDEMIC OF 1904

April 19, 2004

Typhoid fever is a frightening disease found mainly in third-world countries with primitive sanitation. The symptoms include high fever, cough and sore throat, abdominal pain, diarrhea and, in complicated cases, intestinal hemorrhaging, meningitis, psychosis and...perhaps you've heard enough.

The death rate is about 2 percent in treated cases, but it was much higher in Eastern Maine a century ago, where third-world conditions were as normal as they are in much of the undeveloped world today. The typhoid epidemic that winter was well documented.

On the morning of January 29, 1904, fire destroyed the McEwen Block on Penobscot Avenue in Millinocket. In order to build up enough water pressure to fight the inferno, rotary pumps at Great Northern Paper Company were turned on to suck water from the Millinocket Stream into the town's water system.

A foul odor was detected as firefighters futilely pumped thousands of gallons on the blaze. That was probably because the intake opening for the mill's pumping station was located just fifteen hundred feet and twenty-five hundred feet, respectively, downstream from two outlets for the town's sewer system.

The result was a devastating typhoid epidemic that struck not only Millinocket, but also the downriver communities of Bangor, Old Town and

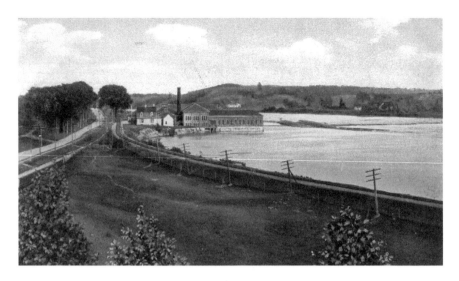

The Bangor Water Works was the focus of efforts to make Penobscot River water drinkable in the early twentieth century.

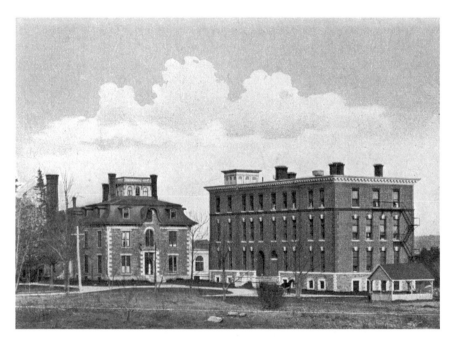

Eastern Maine General Hospital.

Brewer—all towns that got some of their public drinking water from the Penobscot River into which the Millinocket Stream flowed.

When the Windsor Hotel burned down three weeks later, Millinocket firefighters again built up "fire pressure" by pumping water from the same stream, apparently aggravating the situation.

In early April, Dr. A.G. Young, secretary of the Maine State Board of Health, issued a boil-water order for every town below Millinocket using river water for drinking. But by then the dreaded disease was out of control. Before it was done, well over one thousand people were sickened and dozens died, including twenty-two in Millinocket and approximately fifty in Bangor. Nobody died in the two fires.

The doctor who investigated the Millinocket outbreak for the Maine State Board of Health felt certain that it was caused by sewage having been pumped into the drinking water supply while fighting the fires. He noted that the disease infected people living in Millinocket proper, which was supplied with public water, at a much higher rate than those living in neighborhoods like Little Italy and Shack Hill, both of which relied on wells.

After the disease spread to Bangor, a debate began over whether it was time for the Queen City to find a new water supply. Many people did not want to spend the money, and skeptics remained unconvinced that the cause of the outbreak was drinking river water, even though the weight of scientific opinion—including that of the entire Penobscot County Medical Association—was against them.

Dr. Galen Woodcock, a local member of the Maine State Board of Health, told a *Bangor Daily Commercial* reporter on April 9: "In my opinion the city of Bangor needs a new water supply, some place where the drinking water may be obtained and which can be absolutely protected for 50 years to come."

Public outrage was growing. "I have a child who goes to school and also is dear to me…Let us not force them to drink in school hours what is not fit to give a horse," wrote E.M. Gray in a letter to the *Commercial* on April 13.

The Penobscot north of Bangor was no longer the pristine stream it had once been. On April 29, a *Bangor Daily News* story noted:

> *As it is at present, the sewage from communities with a total of 25,000 or more people empties into the Penobscot River, almost half of which comes in at points but 12, 10, eight and five miles above the intakes of the Bangor water works. Within the former limit are two large pulp mills and two woolen mills, which also empty the waste directly into the river.*

The state assayer, O.W. Knight, a Bangor resident and a chemist by profession, described the water that came out of his tap:

> *In spite of the efficient work said to be done by the filter at the water works,*
> *I still continue to find fragments of rotten wood swarming with animal life*
> *in the filter which I have attached to the faucet in my home.*

Outside experts were summoned. One of them was Professor Franklin C. Robinson of Bowdoin College, who concluded that the city's water was unfit to drink much of the time, even though he found evidence of the "colon bacillus" only once during a year of testing. His views were summarized in the *Commercial* on June 15.

But it was a local study by the Citizens League, a new association of young business and professional men interested in municipal affairs, that probably tipped the scales. They interviewed nearly every doctor in Bangor and tracked down 540 typhoid cases that had occurred between March 1 and May 24. Then they created a map showing the proximity of the cases to the public drinking water supply. They pointed out that there were hardly any cases in areas of the city without public drinking water, or in towns such as Orono and Hampden, where most people got their water from wells.

The committee went on to demonstrate that Bangor had a higher death rate from typhoid than New York, Philadelphia and many smaller places. "The conclusion is inevitable that something is the matter with our water supply," asserted the league's investigators in a report dated May 24.

Nevertheless, some skeptics, including Mayor Flavius O. Beal, who was running for the Republican gubernatorial nomination, and the city's water board were still voicing the opinion that the recent drought, not the river water, was to blame. They pointed out a few cases that had occurred in people who did not drink river water. The disease could come from other sources, such as polluted wells or sick cows.

There was a political element to all of this. The advocates of the status quo represented "business interests" that felt they had been dealt a "staggering blow" without sufficient evidence. They called the advocates for change "grafters" who were trying to help certain financial interests get control of the city waterworks, according to a historical account on file with the Bangor Water District.

While it's hard to believe today, Bangor residents continued to drink water out of the river until 1959, when the city switched to Floods Pond.

Attitudes changed, however, in 1904. Between then and 1910, Bangor built a new water filtration system, which put an end to typhoid epidemics in the Queen City.

TB AND THE BATTLE OVER SWEEPING THE BRIDGE

August 14, 2006

The battle over how to sweep the bridge between Bangor and Brewer a century ago may not have been a milestone in the treatment of tuberculosis, but it helps us understand the terror and confusion that once surrounded the dread disease. While a host of health concerns have replaced TB, modern science is in a better position to fight them today than it was then.

The span, located where the Penobscot Bridge is today, had been a covered toll bridge. By 1906, the roof was gone in the middle because of an ice jam that had battered the structure four years earlier. And even though people still called it "the toll bridge," no tolls had been collected since two years before, when the cities had purchased it from the bridge company.

After two of the men who swept the bridge's floor died of tuberculosis, the *Bangor Daily News* launched an editorial campaign in the spring of 1906 to change the timing of the sweeping. The newspaper declared that the sweepers had been perfectly healthy before they started working on the bridge. They had contracted TB from inhaling dust that rose in clouds as they swept. It was composed of "vegetable and animal matter…known to be

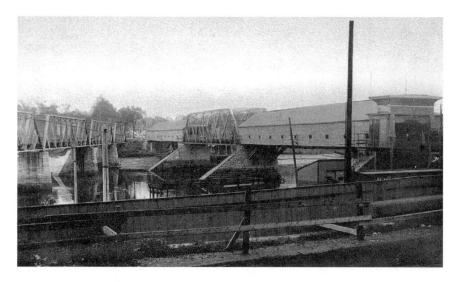

The Bangor–Brewer Bridge was rebuilt with a steel span in the middle after a freshet knocked out its midsection in 1902. *Courtesy of Richard R. Shaw.*

a very favorable breeding place for tubercular bacteria…mingled with the sputa [spit] from consumptive patients." The newspaper said it based this conclusion on the statements of unnamed Bangor doctors.

To fully appreciate the horror of this announcement, one has to understand that more people died of TB, also known as "the white plague," than all the other infectious diseases combined, including diphtheria, typhoid and smallpox. In 1906, 1,176 Mainers died of the disease. Many thousands more walked the streets in various stages of invalidism, spreading it to family, acquaintances and sometimes bystanders. Delicate, pale individuals who tired easily or suffered slight persistent fevers were suspected of harboring the illness. Mothers fled with their children when they encountered a persistent cougher in a public place.

A sense of hopelessness prevailed. "The majority of people believe that tuberculosis is hereditary, and more than that, they believe it is incurable. This leads to neglect during the early months, and takes from many their only chance of recovery," wrote Dr. E.H. Bennett of Lubec in 1905 in the journal of the Maine Medical Association. In fact, the death rate from TB had declined dramatically between 1892 and 1909 thanks to public education about how it was spread.

Treatment consisted mainly of rest, fresh air and nutritious food. Most people died, however, if the disease had passed the initial stages. Sanatoriums, including a state institution in Hebron, catered to these early cases, but there were far too few beds even for them. People with advanced cases were sent home to die, often spreading the disease to others. The state encouraged local health boards to make sure their rooms were thoroughly disinfected after the patients died.

The state also encouraged the availability of burnable "spit cups," but frequently consumptives avoided using them in public because of the social stigma. Debates raged on such issues as whether TB patients should be allowed to spit in the street as opposed to on the sidewalk. "There is no objection to the man spitting around out doors all he pleases," advised the state's secretary of health in a report around this time. "The great danger from tuberculosis patients is of spitting around indoors."

One out of every ten people ailing and unable to work in New England was afflicted with consumption, said the *Bangor Daily News*. Many consumptives walked between Bangor and Brewer on the toll bridge, where, of necessity, they sometimes had to relieve themselves of the noxious material emitted from their diseased lungs. The sweepers on the Bangor–Brewer Bridge should be doing the job late at night when nobody was around, protested the newspaper. Even if the dust were not "seeded with the germs of death," no one would want to inhale it, said the editorial writer on April 27.

In an editorial on July 25, the newspaper revealed it had won a partial victory. The city had started sprinkling the dust with water on most of the bridge before sweeping it, but the job was still being done during the day, when the span was congested with people. Perhaps 10 or 20 percent of the dust continued to rise with the breeze, "disseminating death."

The editorial writer indicated that the doctors who had warned the newspaper about the problem had included "Dr. Woodcock and his associates." Dr. Galen M. Woodcock had been active in fighting two recent smallpox epidemics as chairman of the Bangor Board of Health. He was now a member of the Maine State Board of Health.

By August 22, the editorial writer, sounding a bit weary, had apparently decided to accept this partial victory. It was a step in the right direction. There were so many other battles to fight. The writer pointed out, nevertheless, that "the known presence of a deadly disease in the dust of the bridge can hardly induce newcomers to make Bangor or Brewer attractive health resorts."

Although TB remains a major international problem in third-world nations, effective medicines to treat it were developed in the 1940s, reducing the illness almost to a footnote in Maine. In 2005, there were only seventeen cases in the state. At particular risk are people with impaired immune systems. For most people, TB is only a bad memory, if they have any memory of it at all.

SMOLDERING DUMPS POSED NUISANCE

May 19, 2008

Many readers remember the days not so long ago when every town had an open dump that was the source of smoke and other odors, water pollution and litter. A century ago, things were much worse. Cities like Bangor had many of these dumps, both public and private, scattered wherever vacant lots were available. They added to the pall of smoke from coal and wood fires in homes and factories that hung in the air.

Bangor city fathers moved to alleviate the problem, as described by a *Bangor Daily News* reporter on May 15, 1908:

> *The "dump" question, which has been agitating Bangor for some time, has been settled in a manner which causes unlimited satisfaction to citizens… for a long time there have been complaints regarding the disagreeable and unsanitary condition of the dumping places throughout the city. These rubbish*

refuse heaps were located everywhere and were most unsightly. There seemed to be no regulations, and, if there were, they were totally disregarded.

That spring, Mayor John Woodman took action with the assistance of Street Commissioner Charles Woodbury and the city council. They decreed that from now on there would only be two public dumps—one for the city's East Side and one for the West Side (on either side of the Kenduskeag Stream)—and they would be closely tended by municipal employees.

The West Side dump was located on Sidney Street in a deep hollow between the ends of the street that was supposed to connect Third and Main but had never been completed. It would serve as fill so the two parts of the street might eventually be connected. The East Side dump, which was above Stillwater Avenue on Essex Street, had been used for many years.

All other public dumps would be closed. They included one particularly notorious mess on Pier Street, where the fire department had been called out many times. Others were at Lincoln and Third Streets, on Drummond Street and at Pearl and Garland Streets. The latter spot had become the source of a great deal of neighborhood litter.

Private dumps could remain open as long as the owners kept them from littering nearby property. No mention was made of public burning, however, which apparently was still acceptable, being only a small part of the smoke that billowed out of household and factory chimneys in those days.

While the dump issue was being settled (for the time being), another air pollution problem, located right in the middle of downtown Bangor, came to the fore. It gives us an idea today of the odors that assaulted the nostrils of city residents back when piles of horse manure decorated the busiest streets and outhouses were still scattered about the landscape.

The stables and other buildings on the Hayford lot at the corner of Hammond and Franklin Streets were at the center of a controversy dividing Bangor. The city had seized the land by eminent domain for a new library, but the owners of the property refused to sell it for the price offered.

The Hayford heirs had lost their battle in the Maine Supreme Court, but their lawyer had threatened to take the case to federal court. Some powerful advocates of seizing the property, like the *Bangor Daily Commercial*, urged the city to give the heirs the money already offered, clear the lot and build the library. The *Commercial's* editorials adopted an environmental argument to advance the case.

"Menace to Health," the *Commercial* proclaimed on May 23. "Unhealthy Vapors Rising From Neglected Sheds and Stables are Incubators of Disease."

The story continued:

> *Those suffering more than any others perhaps from the evil odors arising from manure piles, closets [outhouses], dirty and undrained, and the other disagreeable features of stable lots…are the occupants of the county building in which the jail and the residence of the sheriff of the county and his family are located.*

An unnamed county official observed:

> *On some days, particularly such warm and muggy days as come during the early summer, when a great deal of moisture is rising from the earth, it is impossible to keep open the windows in the jail because of the unhealthful odors rising from these old sheds and stables.*

Proper ventilation was believed to be essential to health, but "vile odors" could cause typhoid fever and other diseases, it was believed. "If these old sheds and stables and their accumulation of filth are allowed to remain as they are during the coming hot weather, no one can say what the results will be."

The buildings should be cleared away as "an act of mercy for these unfortunates whose lack of moral strength has caused them to be punished by imprisonment." Such stenches undoubtedly existed in other places in the Queen City. The Hayford heirs got a court order in June stopping the city from clearing the lot, and the battle continued.

Horse Pollution Kept Street Crews Busy

June 23, 2008

"Keep Streets Clean," said a headline at the top of a page in the *Bangor Daily Commercial* a century ago. The words were part fact and part exhortation. Bangor, like many cities, was trying to grapple with environmental messes—from horse pollution and dump proliferation to expectorating—which were growing with the population. New techniques and laws were necessary.

The story on June 25, 1908, announced that Street Commissioner Charles Woodbury had inaugurated a new system for keeping the streets clean. A permanent crew of seven men was engaged each day in "sweeping the

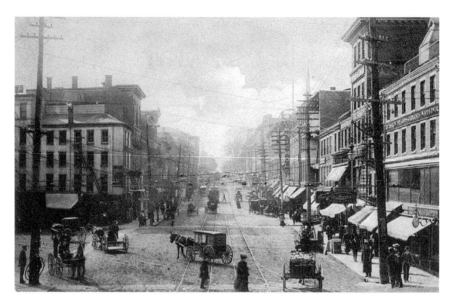

Horse pollution was a major problem in cities like Bangor in the nineteenth and early twentieth centuries. *Courtesy of Richard R. Shaw.*

pavings," picking up wastepaper and other rubbish and depositing it in cans that were placed on the major downtown thoroughfares.

"During the day a cart makes a patrol of the principal streets and the cans are hauled away and emptied of the accumulated dirt and sweepings," said the *Commercial*. "Dirt" was a euphemism for horse droppings. Despite the rise of the automobile, horses were still the principal means of transportation. A horse deposited between fifteen and thirty-five pounds of manure a day, according to my informed source on this important subject, and they were a major pollution problem in crowded cities.

In dry weather, ground-up manure blew around and mixed with the dirt in the streets. When it rained, the streets turned into a quagmire, and crossing assistants helped people navigate the mix of mud and manure in some cities. Many people believed that the odor alone could spread disease. By 1908, however, the medical community knew that flies alighting in this mess were a more likely cause of typhoid and other illnesses than were "vapors." Bangor was not immune to these problems, although the description was muted in the local newspapers.

Thirty new garbage cans and five pushcarts to carry the cans had been added to the city's street-cleaning arsenal. The *Commercial* reported:

An idea of the amount of dirt that collects in Bangor's principal business streets in a day may be gained through the fact that there are 30 cans and they are filled and emptied four times a day, making 120 cans of sweepings every fair day in the summer. On the rainy days when it is impossible to sweep the streets the crew is put to work keeping the crosswalks free from mud.

The average citizen could do his share by visiting those cans when he had some bit of rubbish to jettison, advised the newspaper. The common trash found on the streets back then included peanut shells, burnt matches, cigar and cigarette stubs, banana peels and scraps of paper.

Bangor was a horsey town, and much mention of the mess they created would have offended many influential readers. The automobile was seen by some analysts as a way to clean up the horse problem, but autos would quickly create issues of their own in the years ahead.

Spitting was yet another environmental street problem that plagued Bangor and other communities a century ago. Not only was it disgusting, but many feared it was a way to spread tuberculosis and other diseases. The issue had arisen two years before when the *Bangor Daily News* mounted an editorial campaign to get sweepers on the covered ends of the old toll bridge crossing the Penobscot between Bangor and Brewer to sweep during off hours so the dust they stirred up would not infect commuters with TB germs deposited by those with the dread disease.

In April 1908, the city council passed an ordinance banning spitting on sidewalks and in places of public amusement. The first arrest was made on June 24, when a young man from Bradley was fined one dollar and four dollars in costs for spitting on the floor of the Nickel, Bangor's first movie theatre.

The *Bangor Daily News* commented the next day:

This may seem like a light punishment considering that a similar offense in the larger cities usually brings a fine of $10, but it was the principle of the thing that counted. A few more arrested, members of the police force say, would do much to break up a nuisance which has become disgustingly prevalent mostly on the streets although public buildings have also suffered.

Earlier in the year, Bangor had taken action to tidy up and consolidate its multitude of public dumps. In such ways, the Queen City and many other cities tried to clean up, little understanding that the environmental

problems of that era would be outdistanced by a whole new set of problems in the next.

WATERFRONT FIRE PROVIDED PREVIEW OF HORRORS TO COME

April 21, 2008

Early on the morning of April 16, 1908, a fire was discovered in J. Frank Green's hay shed at 156 Broad Street on Bangor's waterfront. An alarm was sounded at 1:30 a.m., and within a few minutes another alarm was pulled, calling out all the firefighting equipment and manpower in the Queen City.

Feeding on a row of wooden warehouses containing highly flammable materials along the wind-whipped Kenduskeag Stream, the growing conflagration had the potential to destroy the city's waterfront and much more. This, the second fire in Green's shed in a year, appeared to be of "incendiary origin," said authorities.

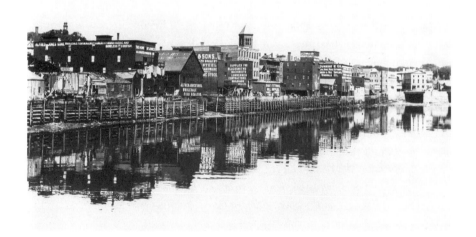

The waterfront fire of 1908, which burned businesses along Broad Street bordering the Kenduskeag Stream near here, started in a hay shed used by J. Frank Green. *Courtesy of Richard R. Shaw.*

This hay shed occupied by J. Frank Green was the spot where the Great Fire of 1911 started. *Courtesy of Richard R. Shaw.*

Bangoreans already had the fire jitters, as did much of the rest of the nation. In March, there was an uproar over school safety after a fire destroyed a school in Collinwood, Ohio, killing 172 children and teachers. Then, just four days earlier, the city of Chelsea, Massachusetts, had gone up in flames. Approximately 19 people died and three thousand buildings were destroyed, touching off another wave of fire fear.

The spring was getting off to a bad start in Bangor. The day before the Broad Street blaze, Thomas J. O'Leary, a fireman, had died of a heart attack while on his way to fight a grass fire on Sidney Street. Then, for a few minutes on the morning of April 16, Bangoreans feared that the worst was happening.

Green sold tar paper, as well as straw and hay. His shed was soon engulfed in flames. "A fierce westerly wind was blowing, carrying great bursts of flames and myriads of sparks directly down the stream," reported the *Bangor Daily News* in its last edition later that morning. Soon the Bangor Tallow Company on one side of the shed and Jacob Cohen's clothing store on the other were burning. Would the flames spread to the Northern Manufacturing Company, where paint was made, and to Bacon & Robinson's coal shed farther down the street? Would the carriage and farm equipment dealer, C.M. Conant, and the "beef houses" operated by Swift and Armour at the end of the street burn as well?

According to the *BDN*:

> *Flames lighted up the entire waterfront and great billows of black smoke bright with sparks trailed off to the eastward. Hundreds came to the scene attracted by the second alarm and the flames which could be seen all over the city.*

Flying embers caused a small fire in the coal shed of J.F. Angley at the foot of Broad Street, but it was quickly extinguished.

The newspaper article continued:

> *The firemen worked under great disadvantage as they were cut off from the rear of the buildings by walls of flames in the alleys, and fierce wind currents drew the flames first one way and then the other.* [Fire] *Chief Mason was cool and used most excellent judgment in placing his lines.*

Thousands of gallons of water were poured on the Cohen building, as well as on the Bacon & Robinson coal shed.

Damages were estimated at somewhere between $15,000 and $20,000. "But the figures of the loss do not express the scare that the fire gave, as it looked as though at first it would lick up the coal sheds and the Conant plant and the beef houses," said the newspaper. At 2:20 a.m., part of the roof of the tallow plant collapsed with a great crash, and a shower of sparks spread through the night air as far as the Brewer shore across the Penobscot River.

The Queen City was lucky this time, despite the blowing wind and the tinderbox quality of the neighborhood. A metal-sheathed wall between the shed and the building containing Cohen's store and the paint factory slowed the blaze. The quick work of Bangor firemen brought the fire under control within an hour.

That afternoon, the *Bangor Daily Commercial* added some new details to the story. Several firemen had narrow escapes when the tallow company roof collapsed. Lieutenant Parsons's foot was literally nailed to the ground when a falling timber hit it. He asked Chief Mason to pull out the nail and kept working. Four other firemen fell or jumped to the ground, one with a gash in his head.

Extinguishing the Broad Street fire so quickly was "almost a miracle," declared an editorial in the *Commercial* the next day. There were lessons to be learned from both this fire and the one in Chelsea. For one thing, laws governing the erection of wooden buildings needed to be enforced. "Tall

wooden buildings are allowed to be repaired in sections where they should not be built at all—in close proximity to other more permanent structures, near to valuable business blocks." The brush piles and rubbish heaps that littered the city should be removed, as well.

Meanwhile, George A. Cleveland, a Bangor businessman who had witnessed the Chelsea fire from a hillside in East Boston, was interviewed by the *Commercial.* He described a holocaust of enormous proportions, "a wild, crazed, disorganized human stampede" fleeing "volcanoes of flame" that destroyed everything in their path and exploding tanks of oil along the waterfront that produced "flame and smoke as black as the stygian night."

"God grant that I may never have the misfortune to witness [such a scene] again," Cleveland concluded. God spared him from seeing the same awful vision in Bangor almost exactly three years later. He had moved away when, on April 30, 1911, yet another fire broke out on Broad Street in a hay shed used by J. Frank Green—an event surely of interest to connoisseurs of historical oddities—and Bangor finally suffered its own stygian nightmare, still known today as the Great Fire.

BIBLIOGRAPHY

ARTICLES

Day, Holman. "Does Prohibition Pay? Maine After Fifty-seven Years of Prohibition." *Appleton's Magazine* (August 1908).

Reilly, Wayne E. "Eastern Maine—1900." *Bangor Daily News*, January 8, 2000.

———. "Ethnic Bangor: Rediscovering Our City's Past." *Bangor Daily News*, December 1–8, 2007.

Reilly, Wayne E., and Richard R. Shaw. "In Search of the Real Fan Jones." *Down East* (April 1988).

BOOKS AND PAMPHLETS

Angier, Jerry, and Herb Cleaves. *Bangor and Aroostook: The Maine Railroad.* Littleton, NH: Flying Yankee Enterprises, 1986.

Blanding, Edward Mitchell. *The City of Bangor.* Bangor, ME: Bangor Board of Trade, 1899.

Goldstein, Judith S. *Crossing Lines: Histories of Jews and Gentiles in Three Communities.* New York: Morrow, 1992.

Hatch, Louis C. *Maine: A History.* Somersworth: New Hampshire Publishing Company, 1974. Facsimile of 1919 edition.

Heseltine, Charles D. *Bangor Street Railway.* Warehouse Point: Connecticut Valley Chapter of the National Railway Historical Society, 1974.

Ives, Edward D. *Argyle Boom*. Orono, ME: Northeast Folklore Society, 1977.

Judd, Richard W., Edwin A. Churchill and Joel W. Eastman. *Maine: The Pine Tree State from Prehistory to the Present*. Orono: University of Maine Press, 1995.

Lee, Maureen Elgersman. *Black Bangor: African Americans in a Maine Community, 1880–1950*. Durham: University of New Hampshire Press, 2005.

Lunt, Dean Lawrence. *Here for Generations: The Story of a Maine Bank and Its City*. Frenchboro, ME: Islandport Press, 2002.

Mundy, James H. *hard times, hard men: Maine and the Irish, 1830–1860*. Scarborough, ME: Harp Publications, 1990.

Price, H.H., and Gerald E. Talbot. *Maine's Visible Black History: The First Chronicle of Its People*. Gardiner, ME: Tilbury House, Publishers, 2006.

Richardson, John Mitchell. *Steamboat Lore of the Penobscot: An Informal Story of Steamboating in Maine's Penobscot Region*. Augusta, ME: Kennebec Journal Print Shop, ca. 1941.

Scontras, Charles A. *Time-Line of Selected Highlights of Maine Labor History: 1636–2003*. Orono: Bureau of Labor Education, University of Maine, 2003.

Shaw, Richard R. *Bangor*. Augusta, ME: Alan Sutton, Inc., 1994.

———. *Bangor in Vintage Postcards*. Charleston, SC: Arcadia Publishing, 2004.

Smith, David C. *A History of Lumbering in Maine, 1861–1960*. Orono: University of Maine Press, 1972.

The Story of Bangor: A Brief History of Maine's Queen City. Bangor, ME: BookMarc's Publishing, 1999.

Thompson, Deborah. *Bangor, Maine, 1769–1914: An Architectural History*. Orono: University of Maine Press, 1988.

Vickery, James B. *Made in Bangor: Economic Emergence and Adaptation, 1834–1911*. Bangor, ME: Bangor Historical Society, 1984.

Vickery, James B., ed. *Bangor, Maine: An Illustrated History*. Reprinted by Bangor Bi-Centennial Commission, n.d.

Wasson, George S. *Sailing Days on the Penobscot*. Salem, MA: Marine Research Society, 1932.

Zelz, Abigail Ewing, and Marilyn Zoidis. *Woodsmen and Whigs: Historic Images of Bangor, Maine*. Virginia Beach, VA: The Donning Company/Publishers, 1991.

NEWSPAPERS

Bangor Daily Commercial
Bangor Daily News
Industrial Journal

THESES

Banfield, Alfred T., Jr. "The History and Ethnicity of Italians in Maine."
 Master's thesis, Liberal Studies, University of Maine, 1989.
King, Donald J. "Leisure Time Activities in Bangor, 1865–1901." Master's
 thesis, History, University of Maine, 1961.

ABOUT THE AUTHOR

Wayne E. Reilly worked for the *Bangor Daily News* for twenty-eight years as a reporter, an editorial writer and an assignment editor. His freelance writing has appeared in many other publications, and his work has won many professional and civic awards. Using family diaries and letters, he has edited two books, *Sarah Jane Foster: Teacher of the Freedmen* and *The Diaries of Sarah Jane and Emma Ann Foster: A Year in Maine During the Civil War*. Since his retirement from the *Bangor Daily News*, he has written more than 250 columns on Maine and Bangor history for the newspaper.